Concept to Print

Advanced Techniques in Creative Portraiture

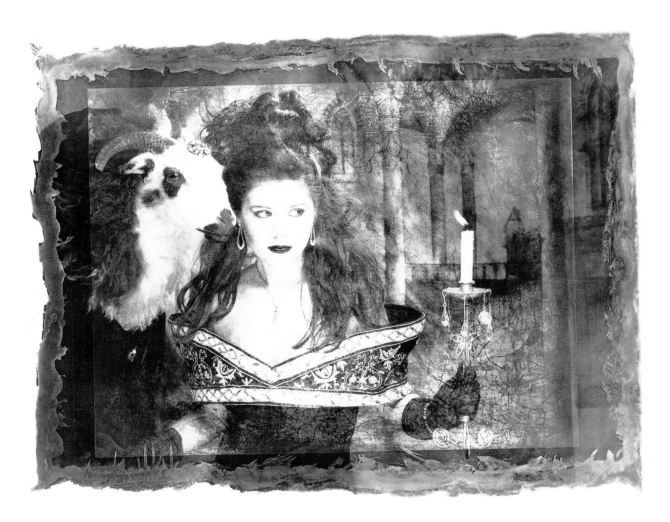

By Stu Williamson with Jon Tarrant

SILVER
PIXEL
PRESS

Rochester, NY

D1275482

First North American edition 1998

Published by
Silver Pixel Press®, A Tiffen® Company
21 Jet View Drive, Rochester, NY 14624 USA
Fax: 716-328-5078

Printed in Singapore by Imago

Originally published in the UK 1998 by Argentum,
an imprint of Aurum Press Ltd

Illustrations: Dave Matthews @ Graphic Creations,
Design & Illustrations, Falmouth, Cornwall, England
Prepress: Graphic Ideas, London, England

Library of Congress Cataloging-in-Publication Data

Williamson, Stu, 1956-
 [Stu Williamson's concept to print]
 Concept to print : advanced techniques in creative portraiture /
Stu Williamson, with Jon Tarrant. -- 1st North American ed.
 p. cm.
 Originally published: Stu Williamson's concept to print. London :
Aurum Press, 1998.
 Includes index.
 ISBN 1-883403-28-6
 1. Portrait photography. 2. Composition (Photography)
I. Tarrant, Jon. II. Title.
TR575.W55 1998
778.9'2--DC21

 98-19172
 CIP

Cover Image: **Louise**, printed on Ilford RC paper, lightly bleached and
selectively tinted with a yellow photodye (see page 48).

My thanks and gratitude go to all those who have helped me in the past. Rather than risk leaving someone out, I thank you all.

Special thanks to;

Agfa
Bowens
Colorama
Contax
Eastman Kodak Company
Elinchrom
English, Terry
Fotospeed
Fuji

Ilford
Johnson's Photopia
Lastolite
Matthews, Dave
Pentax
Photonbeard
Sola Wetsuits
Tetenal

I would like to also thank all the models without whose help, and effort, none of the images in this book would have been possible;

Amanda
Angie
Correna
Dee
Debbie
Eve
Jeff
Jo
Hannah

Helen
Kate
Louise
Mandy
Michelle
Phillipa
Sarah
Simon
Tanya

Contents

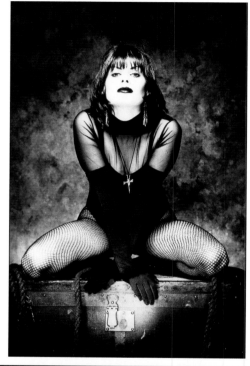
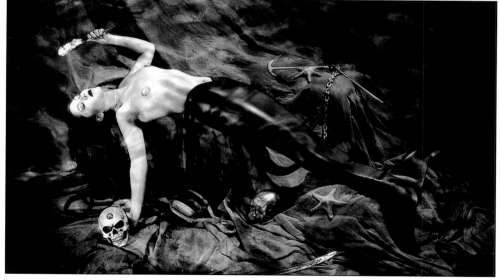

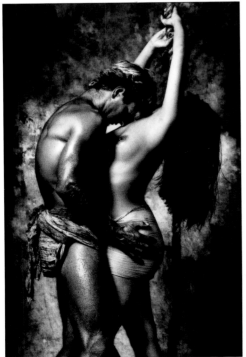

Foreword

Trying to construct better images is a difficult task and I have travelled thousands of miles to see other professionals at work in an attempt to help me gain as much knowledge as possible. Although quite a lot of the advice was repetitive there were things said and done that I could relate to in my thirst for improvement of all aspects of my photography.

This book has come about after many years of being asked at my lectures if I have any written material available. It is not about the finite technicalities of darkroom or camera work – there are plenty of books on the market already that adequately cover these topics. It is intended to inspire the reader into understanding portraits and their construction, using images from my own portfolio to demonstrate the principles.

I hope you will be able to go beyond my advice given in this book and achieve your ultimate goal – your perfect image.

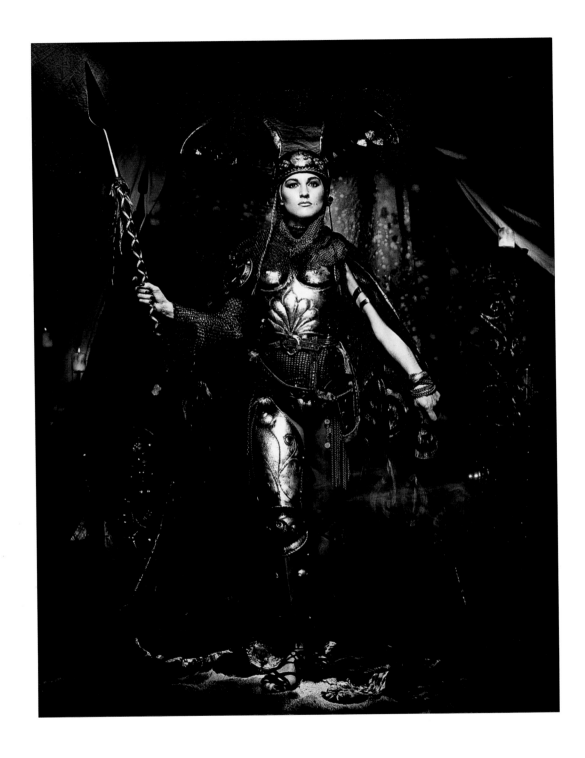

Introduction

The Personal Approach

When you look at pictures what do you see? Photographs should be more than superficial images on glossy bits of paper. They should evoke a reaction. Some of the best photographs tell a story and make you believe in a world that exists beyond the edges of the frame. If the picture warrants further observation, try looking slightly deeper into the image and see what the photographer is trying to say via the contents of the photograph – some clues to this may be given by the use of symbols in the image.

Many years ago, in London's Tate Gallery, I was admiring a painting of Mary Queen of Scots. It was not until a gallery guide explained to me what the phoenix, the dog and countless other things on the canvas meant, other than being there to purely fill space, that I began to assess my whole outlook on paintings and photographs. Even now I try to use this element of expression within my images.

There are two factors that are important once you have started in photography. The first, is the individual artist's or photographer's style, which I believe is a natural in-built expression that matures with the acquisition of knowledge in technique – therefore giving the individual a style. The second, is a collection of rules and guidelines that I will explain throughout this book.

One of my very first pictures (image 1), taken in the early 80's, was lit with a slide projector and shot on a 35mm camera. It illustrates that I already had a clear idea of what I thought made a good photograph, because I automatically printed a high contrast image – although I experimented by incorporating middle tones as well, I much preferred the high contrast version.

Image 2 was taken in the mid 80's and although all the whites are burned-out, because I did not know how to achieve a better print at the time, it still follows the high contrast theme. Image 3 taken in the 90's is where I currently am, hopefully having

Images 1 & 2: A little bit of history. The left-hand picture, with seventies sunglasses and a Peacock chair, was one of my first professionally taken pictures. My liking for high contrast is evident in both of these early images.

perfected my printing and also my control of all the extreme ends of the tonal range.

Why do we take photographs?

I always like to have a good reason to take a photograph and, for me, it is important that the finished print achieves what I set out to state. People will either love or hate your images; it does not really matter as long as they please you.

Photographs need to be more than basic pictures that record and in my images I try to convey a strong emotive sense – such as beauty, mood and depth.

The great painters knew, and know, how to stimulate and many of my pictures are influenced by painters and other photographers. There are pictures in this book that were inspired by photographers such as Bob Carlos-Clarke, Steven

Wader, Horst and painters such as Bruegal, Shalken, and the Pre-Raphaelite brotherhood. I do not mind admitting this, as everyone is influenced during their life in some way by someone. To be original is probably one of the most difficult tasks to accomplish, maybe nothing is – but while influences are acceptable, direct imitations are not.

The best advice I can offer to someone just beginning in photography, or to someone who is struggling to advance, is to stop and think about what it is that they really want to say with their photographs and set out to achieve that aim.

Before going into the studio I always have a general idea of what I want to accomplish. I know that I probably will not get the picture exactly right on the first shot, but at least I have a starting point. For example, image 4 was inspired by the biblical story of the young Rebekah on the Mount.

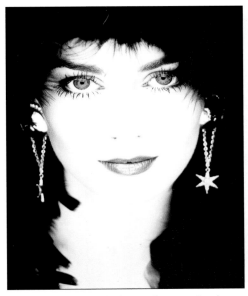

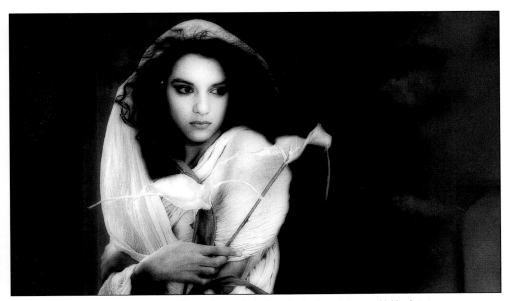

Image 3: It could be said that because the two earrings do not hang at the same angle, this picture is less than perfect. But in this photograph, perfection lies in the model's gaze and porcelin skin.

*Image 4: **Helen with Lillies**. This photograph was influenced by both pre-Raphaelite paintings and biblical stories.*

It is a good idea to keep a scrap book of sketches, photographs, pictures and paintings as these can be a useful reference source from which you can formulate your own ideas.

Throughout this book I have included alternative shots from the different featured sessions. Hopefully this will give you an idea of how near, yet how far, you can be from what you consider to be the correct image. Whatever your choice for the final image, it may not always be the right one unless it has that particular 'X-factor'. Only you will know!

Taking an Image

Initially, when setting out to take an image – be it in the studio or outdoors – I found it very difficult to know where to start. I tried to pre-visualise the final image in my minds eye, but found myself needing to gain a better understanding of picture construction. This was resolved when I went to a seminar by a photographer friend, Charles Green FBIPP, FMPA, FRPS, FRSA, M.Photog.Cr.MEI at which he described his system. Although I have

taken the method a little further, all credit must go to Charles. The system works by using a series of titles which enhance the art of picture making and said as it sounds, the acronym C.L.E.P.S. is easy to remember. C stands for composition, L is for lighting, E is for expression, P for pose and S for space.

COMPOSITION is a starting point and this includes the arrangements of all the elements that will be used in the picture i.e. subject, clothes and props. Many successful pictures incorporate the following guidelines:

1. Rule of thirds.
2. Diagonal lines.
3. Triangular compositions.
4. S and C shapes (curves).

These can be combined to give stability and impact to the image; for example, a diagonal line is intersected by thirds to create dominant points (impact points). The subject, or props, should be placed here to give immediate eye contact achieving an overall balance of the picture. In general, thirds give the picture classic qualities (see

image 5), whereas diagonals suggest greater dynamic energy (see image 6), triangles suggest greater stability (image 7) and S & C shapes suggest fluidity, and change (image 8).

A good idea for learning about composition or structure is to choose a number of images that you really like. They might be some of your own, or from books or magazines. Analyse the images looking for those which place important features on the thirds impact points, those which have strong diagonal lines, those which use triangular compositions and those which rely heavily on curves. You might well find that the pictures you like favour one or two of these techniques. Either way, trying to work out why successful pictures work is a good means of improving your own photography.

In the western world we read text, and view pictures, from left to right. One practical point to remember, is that if you are using a medium format camera with a waist level finder, your composition will be back to front – although the Pentax 67's eye-level viewfinder makes it an exception to this rule. Therefore, when it comes to printing a medium

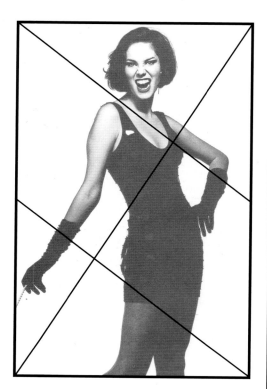

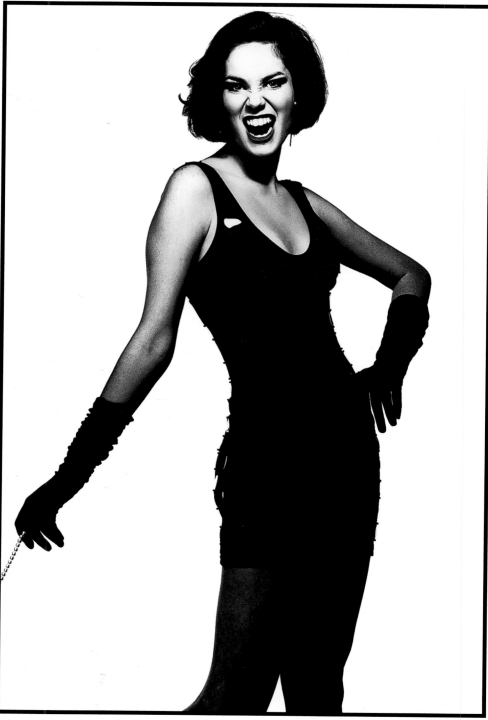

Image 5: **Michelle.** *A good example of using the Rule of Thirds to add dynamic structure. This coupled with the expression creates an unusual but interesting composition.*

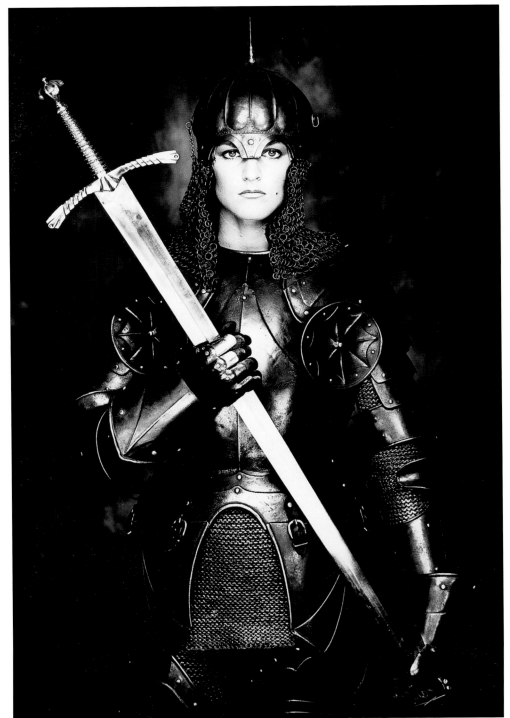

*Image 6: **Excalibur**. Terry English's armour can be seen in all it's glory here. The photograph has a very strong diagonal line, created by the brightly lit sword.*

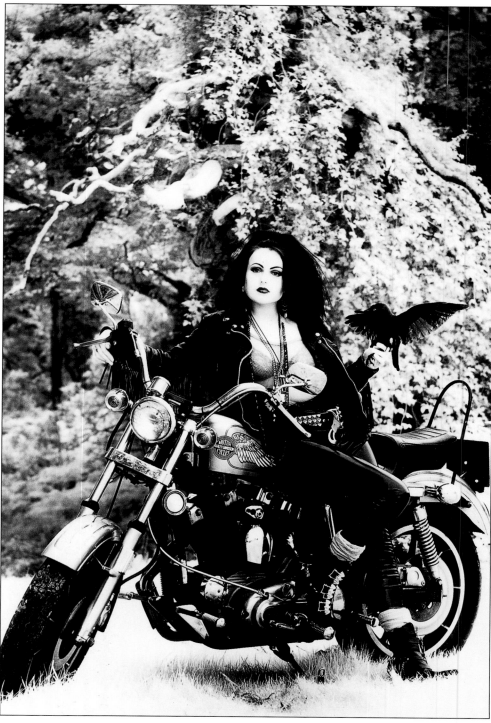

*Image 7. **Ultimate Sleigh Ride**. Taken outdoors on Konica infra-red film using a Mamiya RB67 camera fitted with a 140mm lens, and shot through a red filter, this picture uses a bold triangular composition. The Harley Davidson motorcycle lies at the bottom of the triangle, providing a solid base to the picture.*

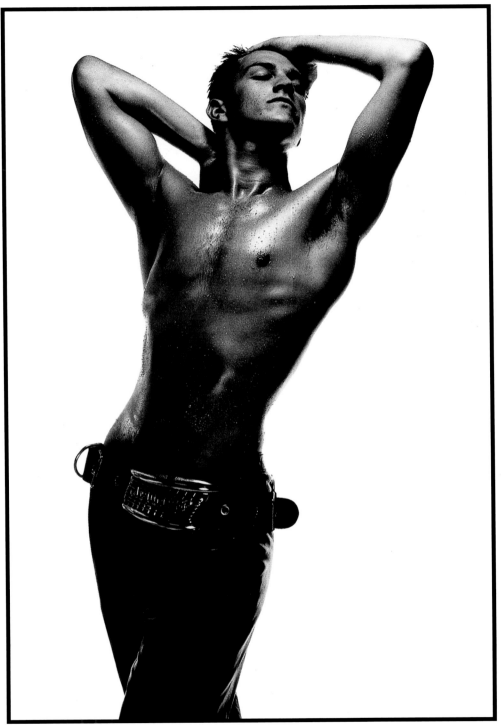

Image 8. **The Hitcher.** *An exaggerated S-shape pose that uses the natural body shape to emphasise its curves. The triangular elbow composition is a good example of varying degrees of C-shapes.*

format image it will print the opposite way to how you had seen it in the viewfinder. If you reverse the negative and then make a print, the resulting image is the one you originally saw in the viewfinder – you might even prefer it.

When I have taken portraits and printed a reversed image it has often surprised me how the subject prefers the reversed print. I presume this is because we are used to seeing ourselves reflected in mirrors, so pictures which are similarly reversed give the illusion of looking more natural (but only to the person portrayed, everyone else is accustomed to seeing the subject's face the right way round).

LIGHTING obviously sets the mood of the picture and therefore the most important thing is to be aware of the characteristics of the chosen light source i.e. soft or hard. You will see in the lighting diagrams, for each of the portfolio chapters, that I try to keep the lighting as simple as possible and I am a great believer in the use of reflectors.

Out of necessity I designed the Lastolite Tri-Flector – a trapezoidal, multi-directional, free standing reflector – and also the Beauty-Flector – that attaches directly onto the softbox and gives a soft, overall light especially flattering for females (see picture on this page).

Once I have chosen the main light source attachment I set to work lighting the subject 'painting' with other lights and, where necessary, using attachments. When looking to purchase a lighting system it is important to consider a brand that offers the widest range of lights and attachments as the use of these can often dramatically affect the lighting set-up – the last thing you want is to settle for using a snoot, when in reality a spotlight would do the job much better.

It is important to do as much as you possibly can with lighting, to minimise corrective darkroom work later, and taking polaroids will greatly assist with this – although there are some things which are easiest done in the darkroom, such as vignetting.

EXPRESSION is paramount because without it there is no picture. For example, when taking a photograph of a group of people, i.e. a family portrait, it does not matter how good the lighting

and props are, the picture is only as good as the worst expression. If we enlarge a head and shoulder photograph of each individual person, they should all be perfect in expression – if this is not the case the portrait will be let down by that element.

So why are some photographer's images much better than others? The lighting is the same, the camera is the same, in fact everything could be the same except one thing – the photographer taking the picture and his, or her, skill at communication. It is this one factor that controls a subject's resulting expression. When you are photographing a portrait, take charge; be firm but friendly.

You will see in some of my female portraits the eyes have quite a lot of whites showing. This is done for a reason; by showing the whites in this way the subject becomes almost virtuous and there is a purity about the person. I often try to mislead the viewer by suggesting the subject is virtuous with the eyes and then giving a totally different message with the remaining overall expression and props.

POSE is probably one of the hardest things to learn and we need a starting point. If you have not 'studied' body language, how do you get to understand what a particular pose or body gesture means?

Apart from the obvious gestures we all use from time to time, a good source for me (other than attending seminars on the subject) was to study as many art books featuring the human form and on how to draw the human body; these feature a wealth of information. Through these reference sources I found most of the best poses are expressions exaggerated by the use of body language.

One piece of advice I would offer is that as photographers we are in a very privileged position, our subjects allow us to enter into their private space, so be vary wary that you do not abuse that position. Most would prefer to be directed rather than handled.

SPACE is about letting a picture breath. The subject could be completely dominating the overall image or could be placed in a small proportion of the image area. On both counts the subject would be comfortably positioned as to complement the overall feel of the picture.

When I take a photograph I tend to take slightly more than I think is necessary because I then have the option to crop in the darkroom; obviously, if an image is too tightly shot in the first place the final cropping choice is limited.

Image 10: When considering a lighting system it is important to look at one that offers plenty of attachments and accessories.

Jo – 1

The concept

When I first started as a photographer I undertook wedding and portrait work, a lot of which was in colour. After seeing the make-over portraits of John and Trish Perrin from the USA, I decided to specialise in stylised black & white photography and at last I found a market for my technique. The main image shown on page 19 is one of my early pictures, taken in 1990, and is one of several images with which I have won numerous Kodak Gold Awards.

How it was done

I have always printed my own black & white pictures as I like to have total control over the finished image. The images I have used here are a good illustration of how being a photographer and printer help each other.

The square-on pose (image 1) is shown not because it works, but because there are so many reasons why it does not! Although there is a good idea lying under here somewhere, the picture is unrefined as it stands. There is good eye contact – which is something I always look for – but the model's arms look heavy, her waist is obscured to one side, the gloves compete for attention, the chain looks out of place and there is even a reflection from the sequinned top on the top of the model's left arm. Having a bare mid-rift was very much the style when this picture was taken, but it looks rather untidy now.

A few simple changes make the world of difference. In image 2, the model's head is raised towards the light, her eyes are closed and she is almost smiling – it is a very relaxed picture. There is the start of an S-shape composition in the pose and the bare waist has been covered by a wide belt. On the other hand, the gloves still demand attention and the earrings and belt buckle are too obvious. You could say the same for the background, but that can easily be made darker during the printing stage.

By the third version (image 3), the picture is really taking shape. Turning the model to face the other way makes the picture 'read' better, while replacing the spotted gloves, with plain ones, and cropping off the bottom of the skirt keeps the viewer's eye within the picture. The belt has been turned to have its buckle at the back and the earrings are more subtle. I have burned-down the background to start to show how the finished picture could look.

Finally, as is often the case, I have made a slight change. Here, it is only a matter of asking the model to open her eyes; everything else is exactly the same, but the difference it makes to the picture is amazing. One reason is the catch-lights in the eyes – these are the reflections in the pupils that bring life to the image.

I deliberately left a slight halo around the model's body in order to separate it from the background and having got the best print, I then toned and hand-tinted the black & white print.

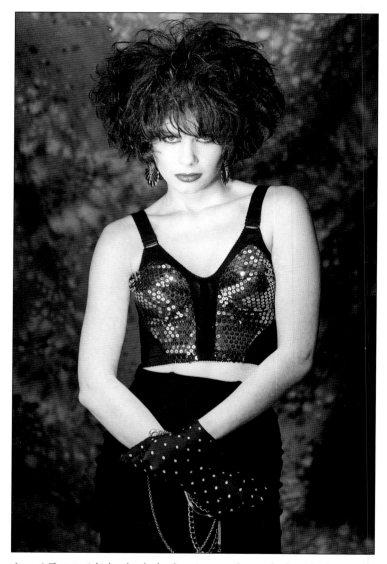

Image 1: The potential is here but the details are incorrect; the pose, the gloves, the chains and the large areas of bare skin all need attention.

An important difference between tinting and toning is that, in many cases, toning is used to colour the entire print while tinting is used for local colour.

I have explained some of my tinting techniques later on in this book, but before doing any tinting you must decide where the colour is needed.

Image 2: Less skin is exposed and the model's pose is more flattering. But the lighting and accessories still need refining.

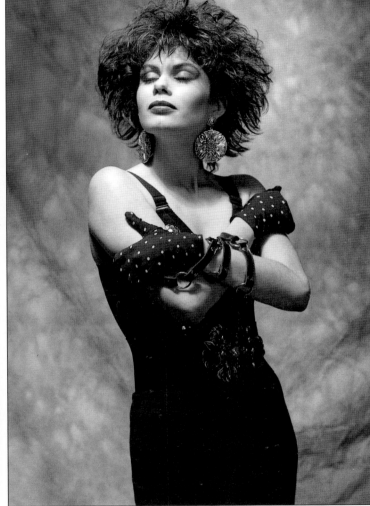

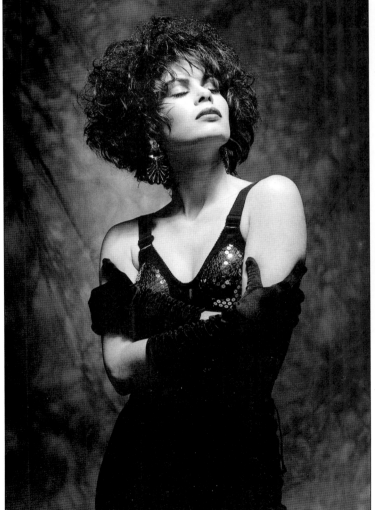

Image 3: Turning the model to face the other way gives a better composition. The longer, plain black gloves are also an improvement but, for me, the closed eyes do not work on this occasion.

Workshop

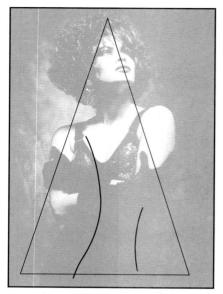

Compositional Rule: triangle and S & C shapes.

TECHNICAL DATA

Model	• Jo	Props	• Gloves, earrings, belts
Camera	• Mamiya RB67	Extras	• Lastolite Tri-Flector
Lens	• 90mm		
Film	• Kodak T-Max, ISO 100		
Background	• Lastolite		
Lighting	• Elinchrom		
Paper	• Agfa Multicontrast FB		
Toner	• Fotospeed		

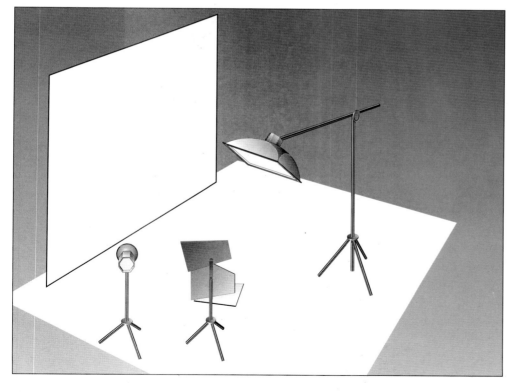

Lighting: *An Elinchrom 44 x 44 attachment was attached to the main light. The honeycomb reflector, normally used in conjunction with the 44 x 44, was removed just leaving the opaque material. This gives a slightly harder light which helps emphasise hair definition and highlights. The tri-Flector was positioned in such a way that a small amount of light was reflected under the chin to help with shadow separation.*

Final Image (right): Although it won a Kodak Gold Award, I ended up printing the image on Agfa Multicontrast FB for this book. I felt this paper gave more definition and bite to this particular image. After vignetting, to create a halo effect, I then locally hand-tinted the top which seemed to add something extra to the photograph.

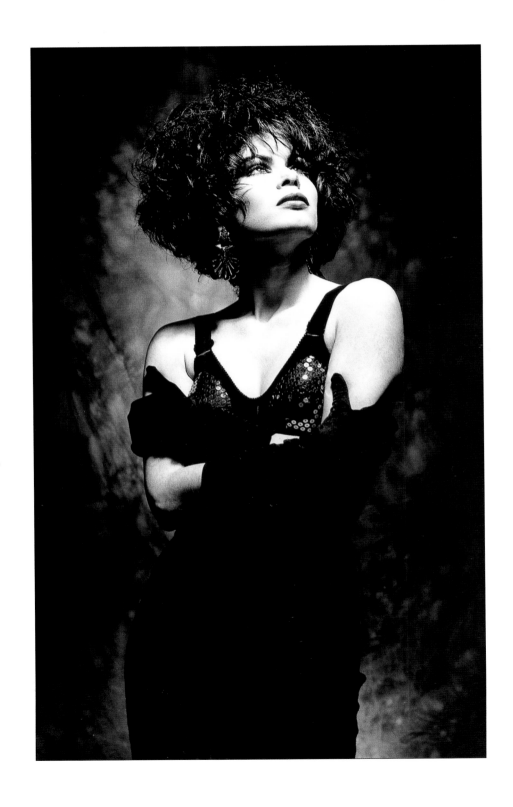

Jo – 2

The concept

This picture was shot for the model's portfolio. All models want to be seen as individuals and once this is discussed you can then focus your ideas and set to work on achieving that individuality.

However, when photographing a folio, I also photograph a selection of casual and head shots, as well as the picture that says something more about the person or the type of work they want to do.

The garments worn by the model in this picture help to add to the erotic overtones of her pose, i.e. one of strength achieved by the triangular composition.

I used an old trunk, rather than an ordinary seat, because its bold shape, and stability, compliment the pose. The extra height it offered also allowed me to give the model a more dominant feel within the picture by shooting from a lower angle — totally complimenting the compositional triangle.

How it was done

As often happens, the first pose (image 3) did not really work. The biggest problem was the model's legs, which were distracting and out of balance with each other and the rest of the picture. The body language is also too defensive — the folded arms create too much of a negative barrier. By unfolding them, and positioning the hands on the knees, the picture would instantly become stronger. This is because a more defined triangular composition has been created making the pose more appealing.

However, after all these adjustments it is purely down to personal choice and I preferred pursuing the route that led to the final image — one that has all the elements of a characteristic image.

The second attempt (image 4) made more of her waist, thanks to the dominant metal belt, although this is not meant to be a picture showing off clothing accessories. Therefore, the belt was taken off and the pose altered (final image). I find

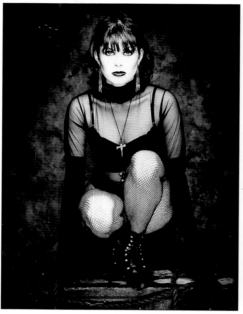

Image 1: A bleached and toned version of my second choice image, showing the different shape vignette — something that would be difficult to achieve using studio lighting.

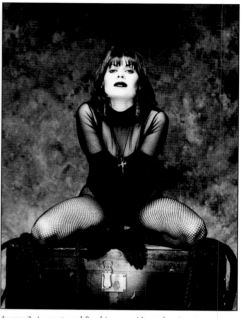

Image 2: An un-toned final image without the vignette.

the angle of the head and the crossed hands slightly erotic and, since I am always trying to get reactions with my pictures, I felt that this was the right pose to use.

The hot-spot on the front on the trunk is a deliberate addition that balances the model's face in the top half of the picture. Rather than using an extra light, I simply positioned a Tri-Flector at the foot of the trunk and used it to focus spilled light from the overhead softbox onto the front of the trunk. A separate flash head was put behind the trunk to light the background and add some separation.

In the darkroom, I slightly vignetted the print. This was achieved by darkening the edges of the image by burning-in (image 2 shows a pre-vignette version). This was done to draw the eye completely to the model and take away the peripheral

distractions. In my experience, vignetting in the darkroom is by far the easiest way to create this sort of look.

The two finished images (image 1 and the final image) have different body shapes, and have been differently vignetted to suit. If graduated lighting had been used — you could do it by metering the fall-off — adjustments would have been necessary with every change of pose, then the spontaneity would have been lost and the 'perfect' pose might never have been achieved.

To finish off the print, I slightly bleached and sulphide-toned it. Just to confirm that I had chosen the right image, I also bleached and toned a vignetted version of the second pose (image 1). I must admit that, in its final form, this pose does look quite good. It also illustrates another advantage of burning-in to create the vignette effect.

Image 3: This image was not chosen because the left leg top section is not balanced with the right leg.

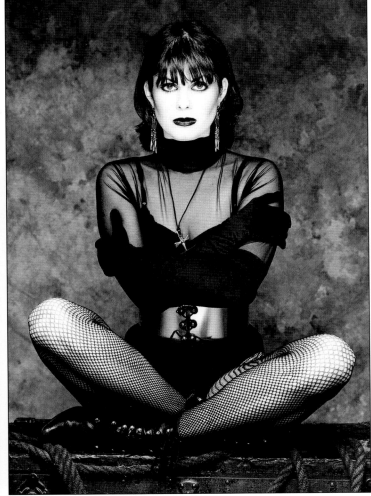

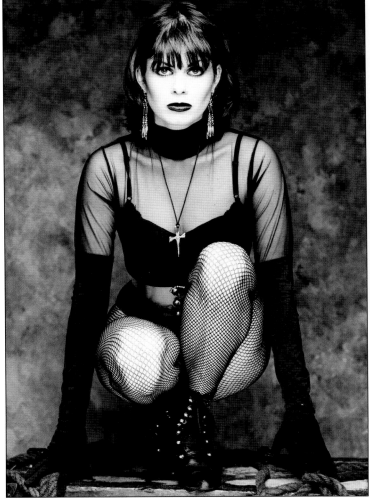

Image 4: It was a choice between this and the final image. This image lacks the eroticism captured in my preferred choice.

Workshop

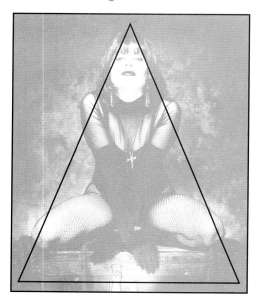

Compositional Rule: triangle.

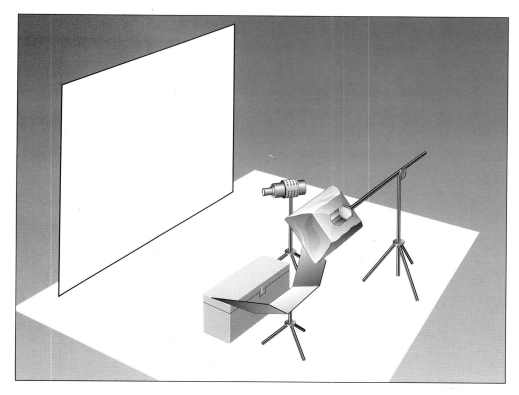

Lighting: *A softbox positioned on a boom was angled at 45° towards the subject. The boom was used so I could take pictures from various angles, unhindered.*

The Tri-Flector was positioned slightly below the case and attached to the centre of each panel was a chrome disc that gave a harder than normal reflection and helped to balance the picture.

The background was lit with a focusing spotlight which gave me the option of either a sharp or diffused highlighted area — I opted for the latter.

Final Image (right): This was vignetted in the darkroom, printed half a stop darker and then bleached back.

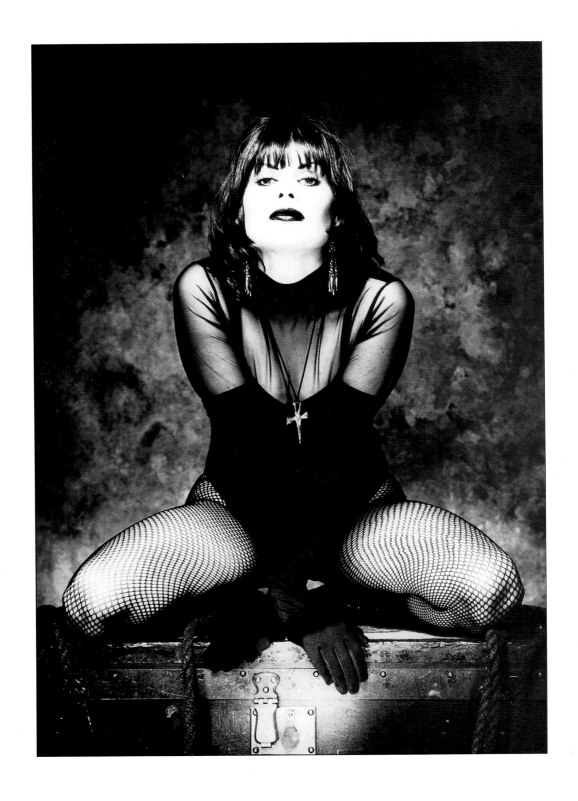

Pagan

The concept

This was one of those pictures that I did entirely for my own benefit. There could well be influences from films like *The Wicker Man,* but there are also sexual overtones. It is a simple, stark picture in the style of an Egyptian hieroglyph, possibly depicting female or animal strength.

Crucial to the success of the image is the plain white back-drop. To get this effect, you must use even lighting on the background. The illumination must be bright enough to give a pure white, but not so bright that it causes flare, which would soften the outline of the model. I used two softboxes, one from each side, both set half-a-stop higher than the lens aperture to ensure an even pure, white light.

How it was done

I worked on several different ideas during this session. One of the ideas was to shoot some of the poses in 35mm format, using a Contax RX body with an 85mm lens (see image 2). The use of a fast film, and this format, resulted in a nice grainy effect when enlarged, and printed. For me, the composition resembles an image in Aztec painting.

However, I preferred the image with the model holding the skull in front of her face. This simple change in the composition gave the picture a totally different theme – one with Pagan overtones. Obviously, this perception is very much down to personal opinion. These two examples show how a little thought and experimentation can yield totally different results.

The biggest difficulty, with the composition I chose, was getting the ram's skull in the right place and at the right angle — given that the model could not see what was going on. This problem is clearly apparent in the rejected image (image 3).

Even before this stage, the hair and skin tones needed attention. Water was applied to the model's hair and baby oil, mixed with coffee, to her body. The coffee was used to enhance shadow

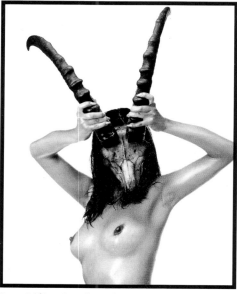

Image 1: Thiocarbamide-toned version of the final print. This is a softer image than the final lith-printed version.

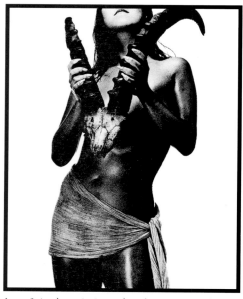

Image 2: An alternative image, from the same session, shot on 35mm film and lith-printed.

definition on the finished lith print and in doing so also help to enhance the stark, gritty effect which can be characteristic of lith printing.

Image 4 shows the full 6 x 7cm frame with the model's leg in the bottom of the picture. This is more than I would include in the final crop, but I always shoot slightly wider to give as many cropping options as possible.

If a picture is cropped too tight, the image sometimes does not have room to breathe and you cannot put space back in if you crop it out at the camera stage. Having said this, the final crop is obviously much stronger than the full-frame version.

I pre-visualised the picture with a golden brown colour, but rather than doing this by toning, I decided to use lith printing.

The difference between toning and lith printing ought to be plain if you compare the cropped, toned version (image 1) with the final lith image

(page 27). The thiocarbamide-toned version is a much softer image than the lith-printed alternative, which shows strong blacks and graphic highlights.

The lith print derives its colour from the combination of over-exposure and incomplete development, which creates a greater than normal amount of finely divided silver. For more information on lith printing, and another example, see *Rapunzel* on page 40.

Composition-wise, look at the firm grip and white knuckles creating tension, together with the twisted, slimmed waist and slightly tilted head. These all add impact.

If you compare the final image with the first pose, you will see that the upright head angle is definitely less dynamic. The impact of this composition is further enhanced by the gritty, high contrast effect of the lith process. Another option would have been to sepia and selenium tone the print which produces a beautiful, rich bronze colour.

Image 3: The problem with this image is obviously that the skull is out of line with the model's face. Also the elbows are too low to give any impact. As well as the baby oil/coffee mixture, water was also applied to the body from a spray bottle.

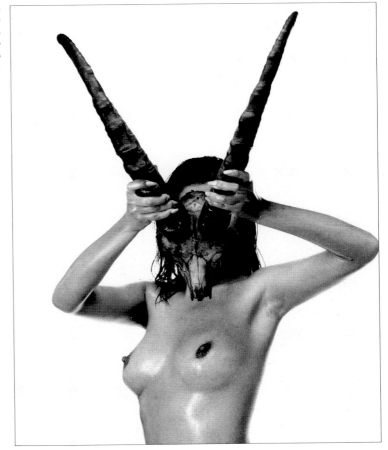

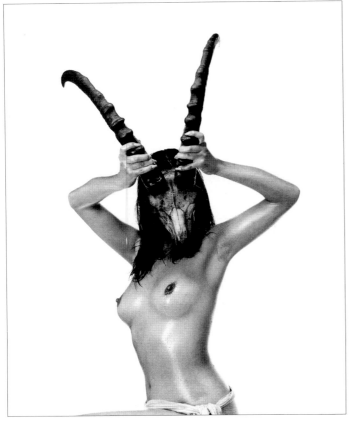

Image 4: The final pose shown full frame. Shooting slightly more gives you the option to crop to your requirements in the darkroom.

Workshop

Compositional Rule: mixed thirds with multi-impact points.

TECHNICAL DATA

Model	• Correna	Toner.	• Fotospeed lith developer
Camera	• Pentax 67		
Lens	• 105mm	Props	• Skull
Film	• Kodak Plus-X, ISO 125	Extras	• Lastolite Tri-Flector
Background	• Lastolite white paper roll		
Lighting	• Bowens		
Paper	• Kentmere Kentona		

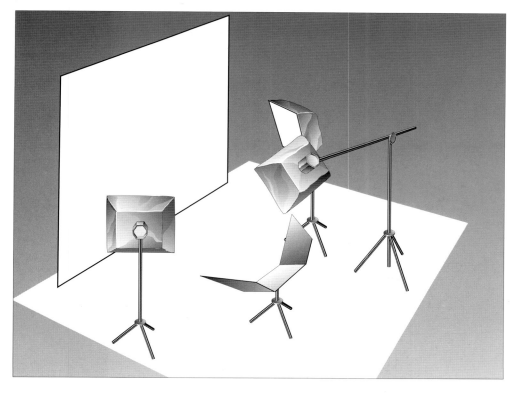

Lighting: *Firstly, to evenly illuminate the background, I positioned two softboxes at a 45° angle. In reality, these could be strip-lights or any number of attachments which evenly distribute light covering the area behind the subject.*

I also chose to light the model with a softbox, having removed the diffusing material, which gave me a slightly harder light. Quite often this is a useful option and eliminates the necessity for changing to a reflector or similar attachment.

Finally, the Tri-Flector was positioned to fill-in and lift shadow areas on the model's torso.

Final Image (right): The final version — lith printed. This picture has a very Paganistic feel. It is a very simple, and stark, picture.

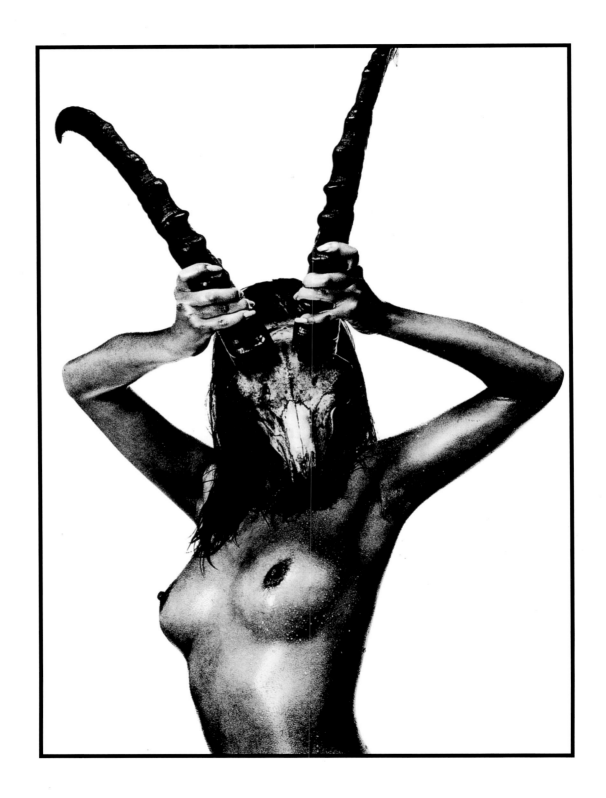

Pagan

Arnemetia

The concept

This was an ambitious picture for which I needed to build a set with Terry English. I wanted to create a picture that told the story of the goddess Arnemetia leaving her pagoda ready to do battle.

As well as wanting this picture for myself, another reason was to get a picture that made the most of Terry English's armour for him to use in his book. The picture was finally shot in Terry's restaurant, Excalibur, as all the props we needed were there on display.

How it was done

When I first started working as a photographer, I had very limited space, and I have tended to work that way ever since. Models are typically about 6-10ft away from the background, though often it is the size of the background, not the studio, that limits this. For this picture, we had to build a complete tent inside the restaurant. It took a long time to put the set together and I had already attempted to shoot this outside, but this proved unsuccessful because of the bitterly cold, February weather.

I was very pleased with the overall look of the picture from my first shot. All that had to be done was to get the pose exactly right and to fine-tune the amount of smoke drifting across the picture.

A powerful set can create a false sense of security and the importance of taking control and trying a variety of poses can be seen by image 2, which does not work.

Increasing the smoke too much turned it into fog, and almost suggested that the tent was on fire! In fact, care had to be taken with the burning candles to ensure that this did not happen.

As well as having too much smoke, the second picture (image 3) is too static; the head angle is too low and the gaze is too personal. If this was to look like a warrior going into battle, the head had to be held higher.

Looking at smaller details, I felt that the model's left hand was too open, too strained. You will see

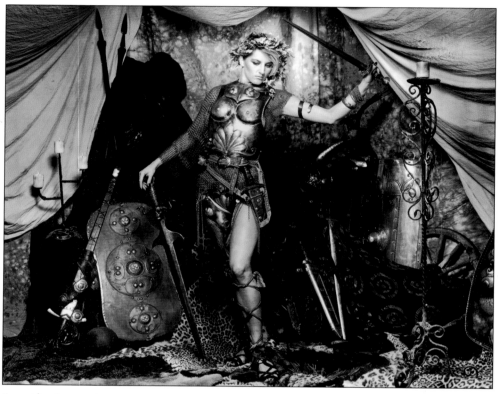

Image 1: Another example from the shoot. It looks more like a victory painting in a classical style. This has also been softened with a stocking placed over the enlarger lens.

that all of these things have been corrected in the final image.

When it came to making the finished print, I did a great deal of fine-tuning, which mostly involved enhancing the lighting. This is the beauty of darkroom work. By the experience of trial and error, and keeping notes, you will soon begin to realise what is possible in the darkroom. Although this is no substitute for good lighting and camerawork, it helps to know what can be achieved under the enlarger lens and with chemicals. So do not be afraid to experiment.

I darkened the top of the image – except for an area around the tip of the spear – and also darkened

the sides, and the floor area, especially the animal skin rug. All this helps focus attention in the centre of the picture.

I knew that the image would be toned and coloured, but I was not quite sure about the balance that I wanted. The final image shown on page 31 has been blue-toned and the armour selectively coloured. I have also bleached and coloured the candles to make them stand out (compare them with the black & white print to see how different they are).

Having gone to all the trouble of building a set I used several completely different ideas, one of which is included above (image 1) in its final form as a toned and coloured black & white print.

Image 2: This image lacks dynamics, particularly the the facial expression and angle. On the day it seemed to work because of the false impression created by the powerful set and props. When printed it simply did not work and this shows the importance of photographing a variety of poses.

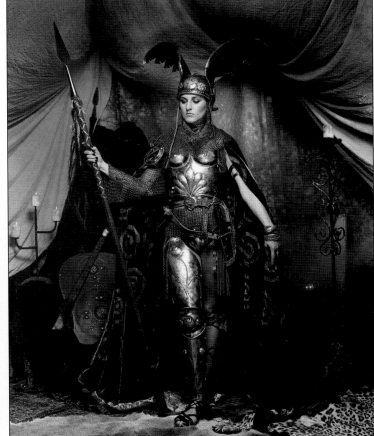

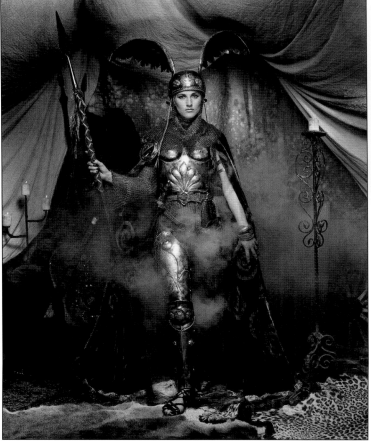

Image 3: The head angle is better, but portrayed more aggression than pride. Also, the model's left hand is too open and there is too much smoke.

Workshop

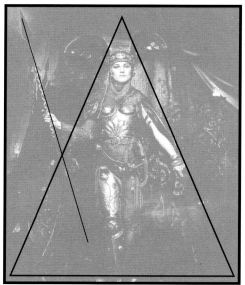

Compositional Rule: triangle and diagonal.

TECHNICAL DATA

Model	• Angie	Tints	• Methods Retouching
Camera	• Mamiya RB67		Inc., New York
Lens	• 90mm	Props	• Selection of
Film	• Kodak T-Max, ISO 100		armour, supplied by
Background	• Lastolite		English Arms & Armour
Lighting	• Elinchrom	Extras	• Lastolite Tri-Flector
Paper	• Ilford MG RC		

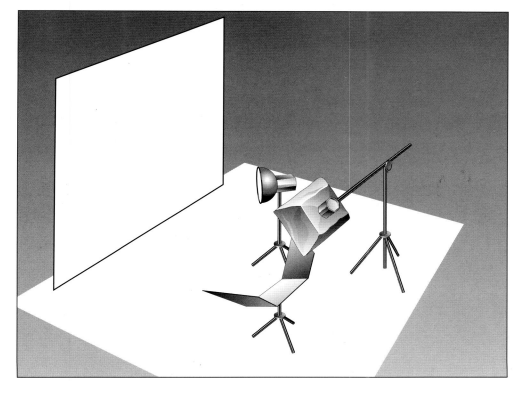

Lighting: The presence of the large set on this shoot could have resulted in unnecessary lighting. Fortunately, common sense prevailed and I opted to light it simply, relying on printing techniques to enhance the mood.
I decided to use a softbox, placed high on a boom, facing the subject at a 45° angle, but, unlike the other images in this book, it was about 12 ft away. This gave the large spread of light I wanted but, at this distance, caused it to be soft and flat. To counteract this I used another smaller softbox to harden the effect.
A Tri-Flector was placed on a floor stand just in front of the model to bounce light into the model's eyes.

Final Image (right): This portrays the strong sense of pride you would expect of a Celtic Goddess about to go into battle. The image was hand-tinted with blue, yellow and orange photo-dyes applied slightly heavier than normally required. It was then quickly submersed in water and fed through an RC infra-red dryer. This weakens the colour and also eliminates all signs of glossy RC surface retouching.

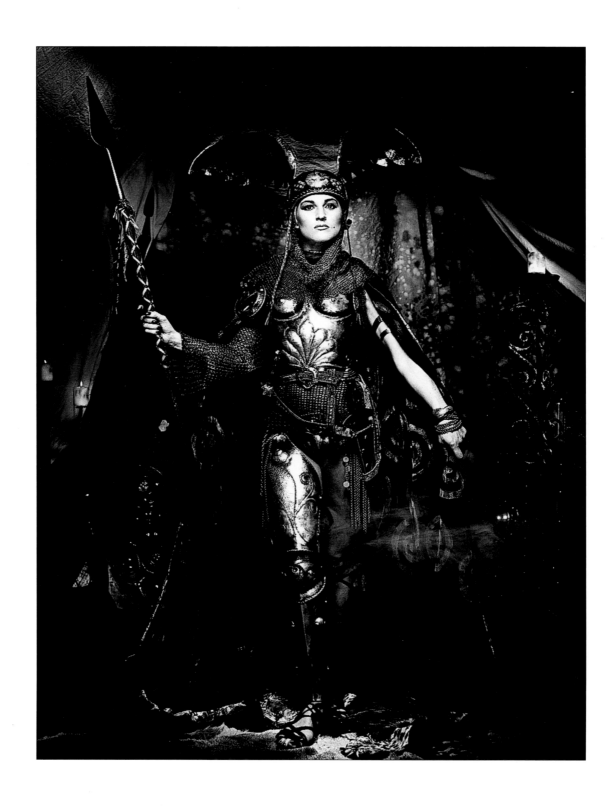

Arnemetia

Beauty and the Beast

The concept

Ilford commissioned a series of fairytale pictures to promote the launch of Delta 100 roll-film. This was my interpretation of *Beauty And The Beast*. I wanted to convey an atmosphere of tension, of the unknown, and decided that the best way to do this would be with a sideways glance and having the candle flame blown to one side, as if caught by a draught sweeping through a large castle room.

How it was done

The background was based on one of Lastolite's standard dappled patterns, painted on to portray a castle interior, which was done for me by a fine-art student. The dress was from a hire company; I make great use of hired dresses that would otherwise cost several hundred pounds to buy. In fact, I hire a lot of my props, including the stuffed ram used in this picture. The make-up was done by the model herself and it took a team of professionals three hours to complete the hair.

I started off without the wind machine so that I could concentrate on everything else. Looking at my first attempt (image 2), you will see that the candle is too high (it blocks the line of sight across the picture) and the ram is too far away (leaving an awkward gap between it and the model).

I have corrected these points in image 3, and have also tried bringing the model's eyes towards the camera. As I originally thought, this has lost the sense of tension — even though the candle flame is now being pushed to the side by the effect of the wind machine. Direct eye contact is generally a sign of strength and that is the opposite of what I wanted here. I wanted the subject to look more frightened.

The key to the whole picture is the eyes and for the final image the model is looking away from the camera adding a sense of drama. This image has also been selectively burned-in, especially on the

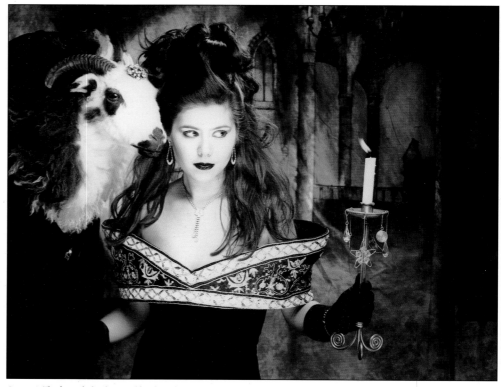

Image 1: The far right background has been burned-in to balance the picture and also create the effect of a darkened room. To enhance the blue, the print can be briefly placed back in the fixer, then washed and re-toned. This gives a much more vibrant tone. Continuation of this method eliminates all mid-tones and results in burned-out highlights if overdone.

right of the frame, to give a stronger feeling of hidden shadows. I tried both blue (image 1) and sepia (final image) toners, and decided that brown was the better colour.

To take the photograph to an even higher level, I printed the final version with a rough border edge. There are several ways that borders like this can be done and I think it is best to experiment yourself to find out what you like.

Try taking a plain (unexposed) piece of printing paper and either paint opaque liquid around the edges or dabb fixer in the middle. Then expose the paper with white light and develop it as usual. If opaque liquid is used, you will need to peel it off

afterwards. When the print is dry, you will have a sheet with either a white centre and a black edge (putting fixer in the middle) or a black centre and a white edge (using the opaque liquid).

This can then be copied onto ordinary black & white film and loaded into the enlarger to create border effects. The white centre original (which gives a black centre when copied) is used when making separate border and image exposures, while the black centre original (white centre when copied) can be sandwiched with the image negative to print everything in one step. Try experimenting with these methods as the resulting effect can be quite stunning.

Image 2: The model is not close enough to the ram and the expression is too soft — it does not give the impression of tension. The fan has not been switched on, so the flame is static.

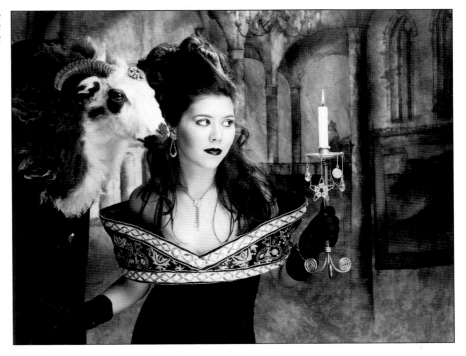

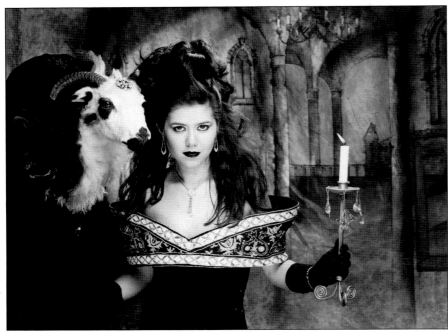

Image 3: Use of the fan captures the candle flame and adds to the perception of a draft. The model's head was positioned closer to the ram and reflects a more intimate feel but she has eye-contact with the viewer. Her expression and overall look is too powerful. I wanted a more frightened look.

Workshop

Compositional Rule: thirds.

TECHNICAL DATA

Model	• Correna	Toner	• Fotospeed
Camera	• Pentax 67	Props	• Stuffed ram,
Lens	• 105mm		candlestick,
Film	• Ilford Delta 100	Extras	• Customised
Background	• Lastolite		background,
Lighting	• Bowens		Bowens jet
Paper	• Ilford MG FB		stream fan,

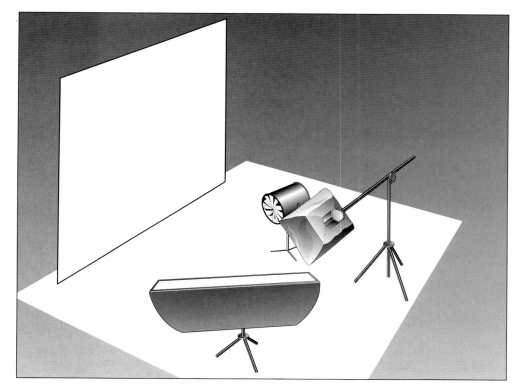

Lighting: *The small softbox was positioned at a 45° angle to the subject and a strip-light was positioned on a floor stand raised at an angle to illuminate and reflect catchlights in the ram's and model's eyes.*
A fan was then placed to the left-hand side of the model, on a slow speed, which put movement into the flame and the model's hair.

Final Image (right): You will see from the images over the page that this has been cropped to add to the intimacy I perceived. I prefer this sepia-toned version to the blue-toned one. When you've achieved your final image and wish to use a toner that involves a bleach bath it's important to remember to expose half-a-stop more than you normally would, rendering the print darker. Also a softer grade of contrast helps keep details that would otherwise be lost in the bleach bath.

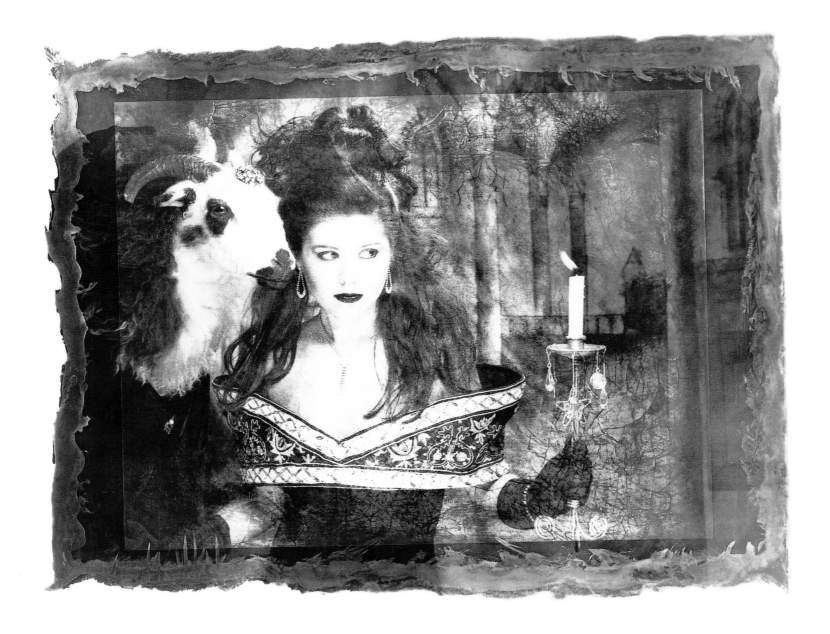

Avalon

The concept

This was one of those pictures that I did for my own portfolio, though Terry English, who supplied the armour, did have the option to use it too. The girl I used initially came along for a model portfolio. I felt that she had great potential and remembered her when it came to doing this picture – I wanted a close-up shot with a far away look, and she proved ideal.

How it was done

There was almost nothing to do when setting up this picture. The lighting was simple and the background just plain paper. Everything rested on getting the right framing and the right look. My first attempt (image 1) failed in both respects; the upright sword catches the light and distracts the eye, the square-on angle is too aggressive for what I wanted and the overall effect lacks energy.

For image 2, I tilted the camera to give a more interesting composition, reversing the sword so that its handle came upwards (so avoiding the flat reflecting blade area). There is potential here, but the handle of the sword is too complex, it is still a distraction. I also felt that the model's gaze was too low, too sad. I needed to show more whites of the eyes, and the easiest way to do that was with a higher, and slightly further off-camera, gaze.

The final image (image 3) takes all these things into account, with the sword turned blade-upwards again, but this time hidden partly behind the helmet and angled so as not to catch the light.

When printing, I cropped more tightly and squarer than the camera's view. On reflection, I decided that the upright format was better, but restored it by cropping in from the sides rather than adding back the areas that had already been cropped out from the bottom of the picture.

The initial exposure was done at maximum contrast before masking the face and burning-in the armour at a softer grade. The eyes were then tinted a very delicate shade of blue, just to lift them slightly. If you look closely, you will see that black lace lines the helmet — a little touch that is intended to give the picture a more feminine feel.

For me, one of the most important features of a portrait is the eyes – they are the windows to our soul. You will see throughout this book that quite often a large amount of white is showing at the bottom of a model's eyes. Photographers describe these whites as 'canoes', because of their shape.

The reason I opt to show the eyes like this is that they portray virtue and purity, and quite often within my images I use the eyes to contradict the overall expression or body language of an image. Over-exaggerating this white – often nicknamed 'cows eyes' – results in a very unflattering look.

As I've already mentioned I also tend to leave all the reflections in the pupils – called catchlights – as I feel this enhances the clarity and sparkle of the eyes.

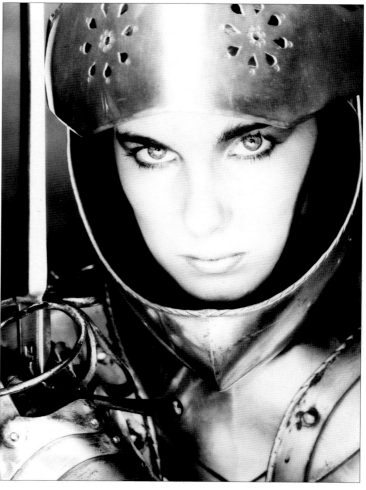

Image 1: Although the head angle is strong, my perception was one of a knight lost in thought. Therefore, eye contact gives the wrong message.

It is a modern myth that dilated pupils should be shown in photographs – as they are supposed to represent physical attraction. This may, or may not, be so in real life, but in a photographic portrait they look lifeless. Making the iris smaller, by using strong lights, brings out the natural beauty of the eye which gives you the option to hand-tint (see *Blue Eyes*, page 64). Not surprisingly, you will find that the eyes are one of the key factors in a good portrait, so never underestimate their importance and pay particular attention to the eyes when photographing your subject, especially with a close-up.

Image 2: I tilted the camera angle and reversed the sword. This did not work because the sword is too dominant and tighter cropping was required. Also the highlight on the shoulder is too distracting. Overall, the image is too loose.

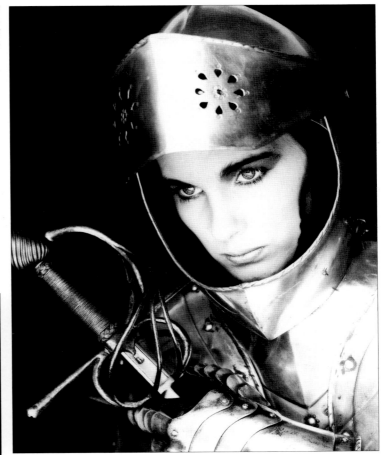

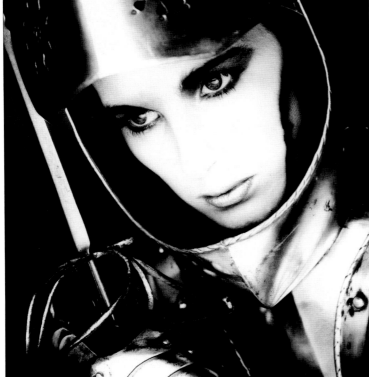

Image 3: The direction of the sword was reversed and tilted to reflect light onto the blade. This compliments the helmet and breastplate seam and enhances the strong diagonal structure of the image. The lace inside the helmet was used to add a feminine feel and a softener was used under the enlarger to further the effect.

Workshop

Compositional Rule: Diagonal crossed with thirds.

TECHNICAL DATA

Model	• Kate	Props	• Black lace, sword
Camera	• Mamiya RB67		netting, armour supplied
Lens	• 90mm		by English Arms &
Film	• Kodak Plus-X, ISO 125		Armour
Background	• Lastolite	Extras	• Chrome reflector
Lighting	• Elinchrom		
Paper	• Ilford MG RC		
Tints	• Tetenal		

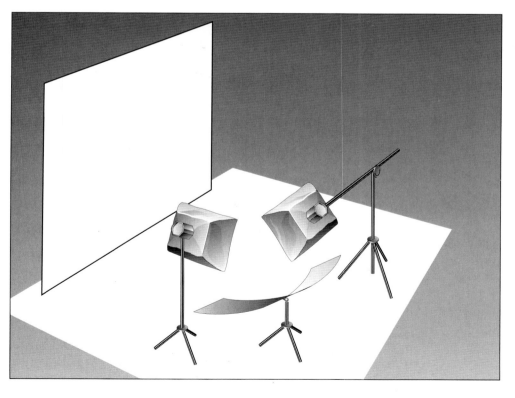

Lighting: *Two softboxes were used — one on a boom that allowed freedom of movement around the subject.*
A chrome reflector bounced light back from the overhead softbox. The other softbox was positioned square-on to the model's face and was used as a fill-light to eliminate shadows cast onto the chin from the chrome reflector.
This second softbox also filled-in shadows on the model's nose caused by the main overhead light.
The overall position of the lighting set-up was very tight to the model. This was to avoid bright specular highlights being reflected from the armour.

Final Image (right): This was left un-softened to ensure an overall sharpness and the eyes were tinted with a blue photo-dye. For me, this enhances the the picture and adds to the power of the expression.

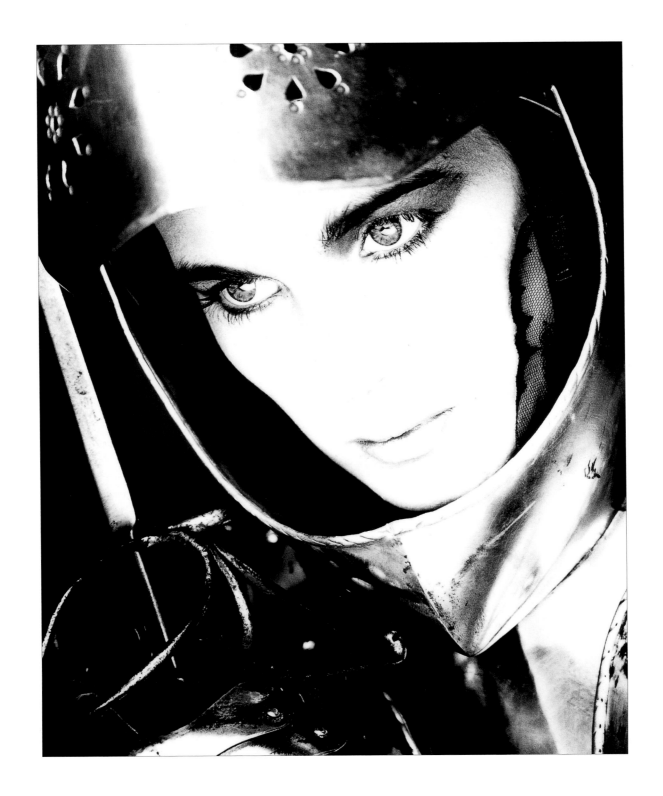

Avalon

Rapunzel

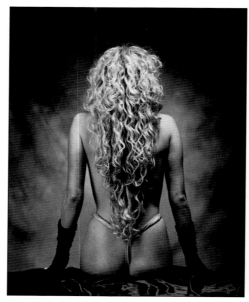

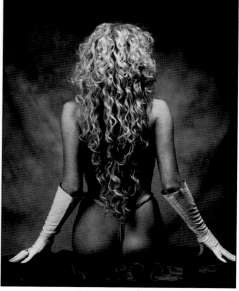

Image 1: The gloves do not work. They are too short and, being black, clash with the satin cloth that the model is sitting on. The arms are too straight and the shoulders are too hunched.

Image 2: The white gloves work much better. Dropping the shoulders and bending the arms slightly makes for a much more relaxed and elegant pose.

The concept

Many photographers have created pictures like this before. I have always liked the idea so I thought I would do my own version – working on a familiar idea like this is a good way of discovering the problems that other photographers face.

You will never end up with exactly the same result because photographers and models differ. What matters is that you put your stamp on the idea; that you produce something you can honestly call your own.

How it was done

I started with black gloves (image 1) — which I have seen used in other pictures – but for me they did not work; they were too dark, they clashed with the satin and they were too short, exposing the elbows too much. As far as the initial pose was concerned, the shoulders were too hunched-up and the arms were too straight.

In image 2, I used lighter-coloured and longer gloves, and asked the model to bend the elbows slightly, and drop the shoulders. These small changes have all combined to give a much more elegant result.

As an alternative, I used a pose (image 3) similar to the one Horst used in his Mainbocher Corset picture, but the shape of the back was wrong. In another shot (image 4), I asked the model to frame her hair with her hands. I quite liked that picture even though it used a completely different composition and almost lost the effect of the long hair.

The only way to decide between the alternatives was to make some small prints and then live with them for a while. These prints were made on Ilford MG RC paper, grade 3 contrast and without any burning-in, or dodging. They allowed me to choose my favourite and also to decide how best to print the final image. In this case, I decided that lith printing would be appropriate.

Lith printing is a rather temperamental process, so be prepared to experiment. Your efforts will be rewarded.

Start by giving the paper two stops more exposure than if it were to be processed normally in standard paper developer. Develop this 'overexposed' print in very dilute lith developer, diluted four times more than recommended for conventional black & white, high contrast images. The lith print will emerge very slowly and initially appear lacking in contrast.

After about five minutes the shadows will suddenly darken. The skill is to take the print out of the developer before the mid-tones and highlights go too dark, as the lith process of infectious development rapidly gathers pace.

A good lith print should have strong black shadows, gritty mid-tones and very warm, peachy-brown highlights. Image colour can be further modified by altering print exposure, developer dilution and development time.

The colour that you see here was given by the developer alone. No toners have been used. Unfortunately, because the chemistry exhausts quite quickly, no two lith prints are ever the same. To complete the effect, the final print was made with a textured screen similar, in type, to that used in *Renaissance Bride* on page 60.

Once the final print was complete it was scanned digitally and, using the Adobe Photoshop software, the distracting highlight on the model's right buttock was reduced by cloning and pasting a section from the left buttock onto the right one. A procedure which would have been impossible using traditional methods, without having to reprint the image all over again.

The resulting, balanced image was then inkjet-printed onto 20 x 24'' French hand-made art paper.

Image 3: This pose is similar to that of Horst's 'Mainbocher Corset' picture, but the shape of the back and buttocks is wrong.

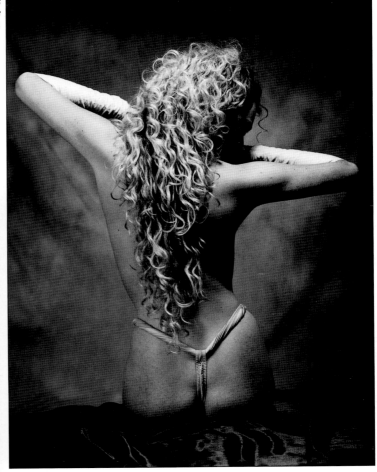

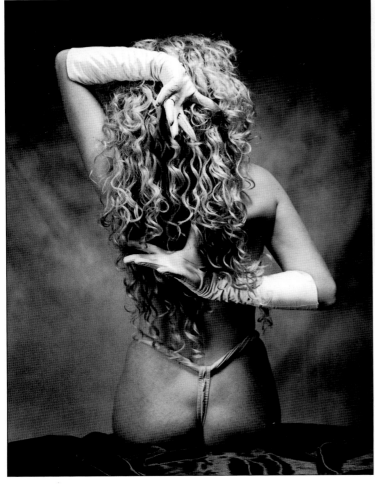

Image 4: Although the position of the arms is uncomfortable, and does not actually do anything for the picture, it is important to experiment in design. This is often how the best images are achieved.

Workshop

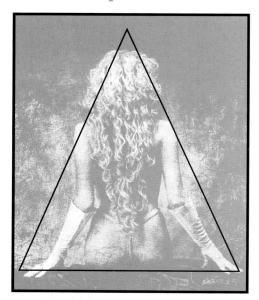

Compositional Rule: triangle.

TECHNICAL DATA

Model	• Sarah	*Paper*	• Kentmere Kentona
Camera	• Mamiya RB67	*Toner*	• Kodak Lith developer,
Lens	• 140mm	*Props*	• Black satin
Film	• Ilford Pan-F Plus, ISO		fabric, gloves,
	50		table, wig
Background	• Lastolite	*Extras*	• Lastolite Tri-Flector
Lighting	• Elinchrom		

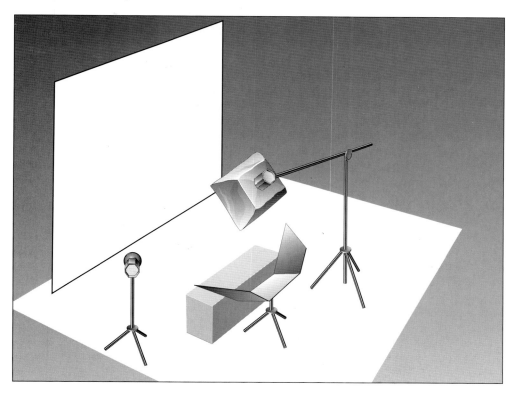

Lighting: *A simple lighting set-up was all that was needed for this image. The lighting consisted of a small softbox, Tri-Flector and a gridded-reflector to illuminate the background and separate it from the model.*
The Tri-Flector was used to fill-in shadow areas on the gloves and balance the bottom of the hair.
The softbox (main light source) was positioned so that it created shadow on the model and slight spillage to partially illuminate the background. In conjunction with the gridded-reflector, this gave a natural vignette effect.

Final Image (right): In this case I decided to lith print and overlay a fresco screen to give the image an early Italian Renaissance look.

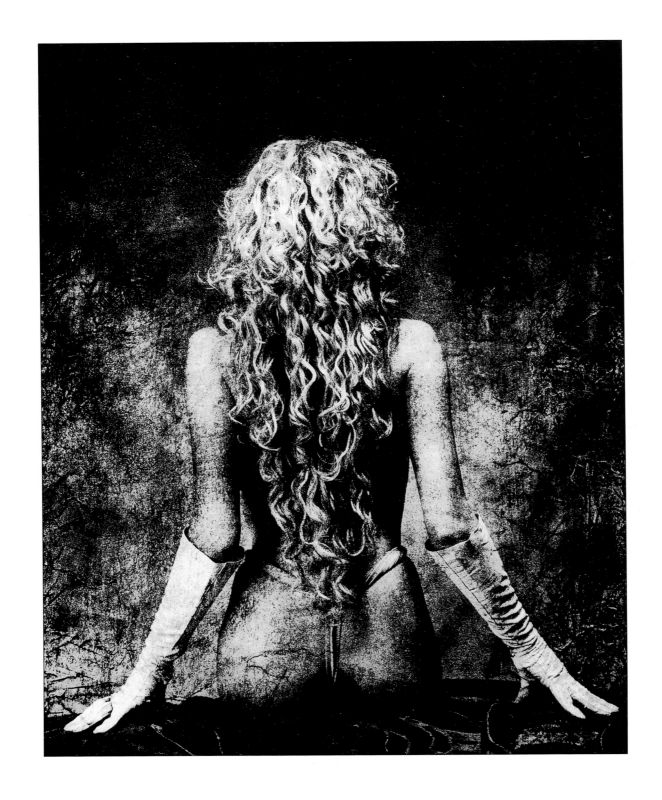

Rapunzel

Bodywork

The concept

I have always admired moodily-lit body shots. Some male photographers definitely shy away from photographing mens' bodies, but I decided I would like to do a series of male physiques. This particular shot was done for the model's portfolio — he is one of the UK's top surf skiers. I wanted a confident pose that showed his ultimate fitness.

How it was done

For a session like this, I ask the model to bring as many items of clothing and accessories as they can. Although the props used here are hardly visible, they are very important. Without them, the images tell less of a story.

The secret to making images like this is to talk them through in advance — do not surprise your model half way through a session. My approach is not aggressive or demanding, but I do work people hard in the nicest possible way. Although it is a serious business when you are taking pictures, you still have to be able to make light of things. Whether you are photographing males or females, it is very important to talk to the model. Do not leave the model thinking, "I wonder what he/she is going to do next?" If you do not want to chat to the model all the time, have some music playing, otherwise you can end up with silence — and that can kill the session.

Initially, I used a pick-axe and chains as props – one in each hand – but it was too much (image 1). Using the story of the picture; a workman breaking from his toil, I dispensed with the chains; it then seemed natural to ask the model to wipe the sweat from his brow (image 2). This looks better, but the ribcage is too dominant. The model's left leg has been brought forward, his left hand grips the pick-axe more firmly and the lighting is better balanced.

Bringing the hand back down and lowering the right shoulder, gives the image a slight tilt (image 3). The result is more dramatic than before. There is also a subtle S-shape to the body, as in the second attempt, where the left leg is forwards for posing and the pick-axe handle is firmly held. The hands are clear of the waistline to leave the shape of the body uncluttered. All lights have been properly balanced to show the stomach and chest muscles to best effect, and a background light provides good separation. If you look at the exposure test print (image 1), you will see that the background light is actually a well-defined spotlight.

Now look at the finished picture (page 47) and you will see that the hard edge of the light has been printed-in to give a much more subtle effect. Once again, this is how I like to work; I use the lighting as the raw materials and refine the effects when I am making the prints.

In a picture like this, the model's face is not as important as the body. That is why I went for tilting the head back as much as I did. There is a very strong

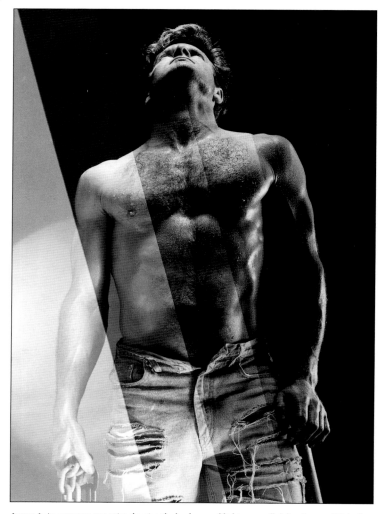

Image 1: An exposure test print showing the background light as a well-defined snooted light that creates separation between the model's right arm and the background. The edges of the light are less defined in the final image but the separation is still evident.

sexual suggestion provided by the undone trouser buttons; the body is almost being lifted out of the clothes! Many male photographers would have a problem asking another man to undo the front of his trousers; yet the biggest problem with inhibitions is that they limit your creativity and stop you taking the best pictures. In this image it is the undone trousers that make this picture work so well – so do not forget that first discussion!

Image 2: An overhead light was chosen to create a sense of mood and strength by casting strong shadows that define the body's upper-torso shape. The strip-light to the right, the floor lights and a spotlight at the back all needed refining to give a balanced image. The image itself does not work because of the protruding ribcage.

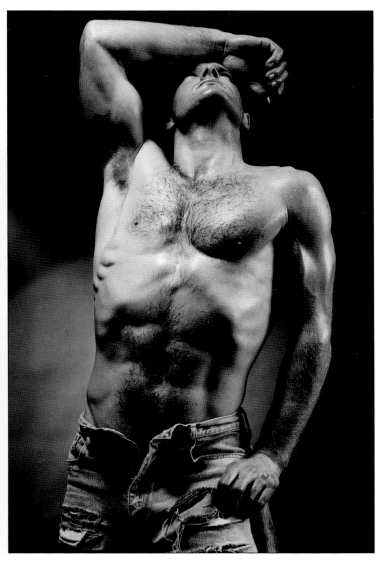

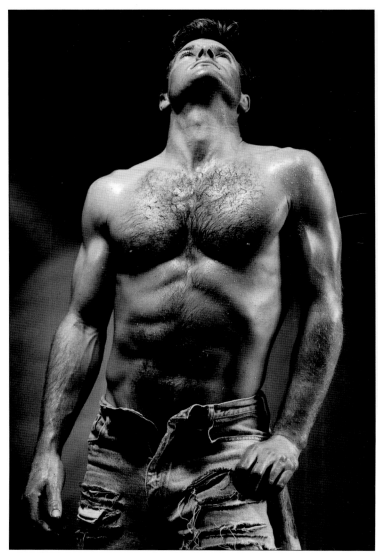

Image 3: The lights in this image are balanced a lot better. Firstly, the floor light has been switched off, the strip-light has been turned down, the overhead light has been pulled forward slightly to give more coverage and on his right-hand side a tri-Flector has been vertically positioned to add highlights into selected shadow areas. It helps to take polaroids when attempting to balance this many lights and reflectors but, as a starting point, set the lights equally and then decide whether to raise or lower everything apart from the main light. Note the forward position of the posing leg. This affects the hips and shoulder position, making the stance more confident.

Workshop

Compositional Rule: triangle.

TECHNICAL DATA

Model	• Simon	Lighting	• Elinchrom
Camera	• Mamiya RB67	Paper	• Agfa Multicontrast FB
Lens	• 90mm	Toner	• Fotospeed
Film	• Ilford HP5 Plus, ISO 400	Props	• Pick axe, ripped jeans
Background	• Lastolite black paper roll	Extras	• Lastolite Tri-Flector

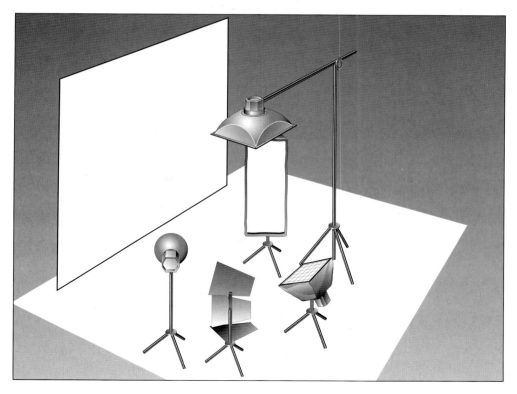

Lighting: *The impact of this image comes from the shadows and specular highlights created, by the overhead light. I selected a 44 x 44 attachment and removed the honeycomb grid which gave a larger spread.*
One barndoor was fitted to stop stray light reaching the background.
A strip-light was positioned to the left-hand side of the subject to illuminate one side of the torso.
To light the background, a reflector fitted with a snoot was used and a floor-light positioned in front of the model gave the option to fill-in the dark shadow area.
Finally, a Tri-Flector was positioned to the right that reflected light into the shadow areas caused by the strip-light and 44 x 44.

Final Image (right): To enhance the overall strength of this photograph, I selectively burned-in areas to darken them and then sepia-toned the image to give it a strong bronze colour. This image also works equally well split-toned in selenium.

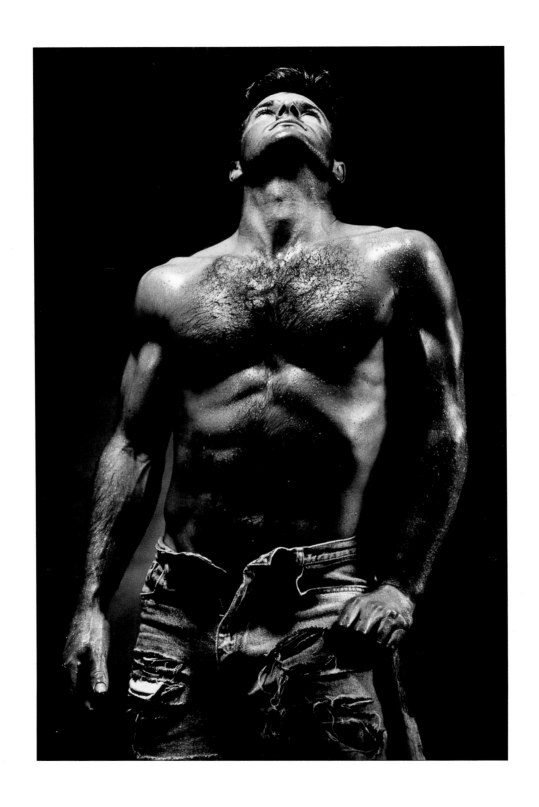

Louise

The concept

Wuthering Heights was my influence for this picture, which was to show a windswept Cathy as she might have looked coming in off the moors. The model's hair is the most important feature in terms of making this picture work. A Bowens Jet Stream fan was used to put life into the hair. This type of fan is commonly found in studios or can be hired for occasional use. The other method to make hair look good is to soften the image very slightly, taking away the definition.

Softening filters can be used under the enlarger or on the camera lens for two completely different results. I prefer to take pictures without softeners and then experiment in the darkroom for the best effect. Under the enlarger, softening filters bleed shadows into highlights (on the camera lens, it is the other way around). The exact amount of bleeding is controlled by the type of softening used. The amount of diffusion is controlled by the strength of the diffusion filter and by the amount of time it is held under the enlarger lens during the print exposure.

In this chapter I have shown some comparative prints that have been softened with a Hasselblad Carl Zeiss Softar Filter #1 and also with two layers of silk stocking fabric – both used on the camera. Because of the shadow-bleeding effect, the model's earring becomes progressively duller as the softening increases. Her necklace, which is surrounded by a lighter area, is less affected by the softening. The hair becomes softer but the model's eyes lose definition to the extent that the most softened print (using two layers of silk stocking fabric) lacks sparkle. To help correct this, adjustments must be made to printing exposures and contrasts.

As a guide, one thickness of silk stocking gives a barely perceptible effect on image quality but loses about half-a-grade of contrast and half-a-stop of exposure. The effect of the Softar filter is similar yet

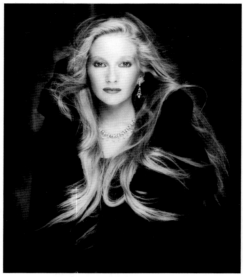

Image 1: Carl Zeiss Softar Filter #1.

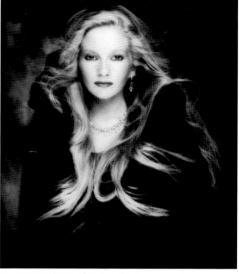

Image 2: Two layers of stocking fabric.

needs no correction for exposure. A double thickness of stocking fabric drops the print by one full grade of image contrast and doubles the required exposure time.

How it was done

In terms of posing, it took several attempts to get the final picture. My first attempt (image 3) had the model holding the hood up around her head. This did not work because the elbows were too distracting, the hair too straight and lifeless, and the expression needed to be worked on.

My second attempt (image 4) was much better. The fan was brought in (located to the left of the picture) to blow life into the model's hair; her hands were brought inside the line of the cape and her head angle was lowered. This is nearly right, but is too static, too square-on to the camera.

For the final image (page 51) the fan was repositioned on the floor in front of the model so that her hair was blown backwards rather than across her face. The arms are still in front, but are

grasping the cape's lapels instead of the tie-cord.

One of the first things I did when I took the negative into the darkroom was to crop it down to focus attention on the model's face. I then tried flipping the negative to see how it looked the other way around. This is sometimes worth trying — particularly when using a camera without a prism finder and the image is viewed in reverse, which can be confusing in composition. Normally, we read from left to right but in the viewfinder of most cameras, with a waist-level finder, it is right to left.

Having decided on the crop and the softening (and keeping the negative the right way around), two final prints were made – one on Ilford MG RC paper, lightly bleached to give it a brown tone (cover image) and the other on Agfa Record Rapid, selenium-toned and then gold-toned to produce a subtle blue (page 51). The brown version was then selectively tinted to give yellow catch-lights in the model's eyes. By doing this it focuses attention on the model's eyes and draws the viewer towards them (also see Blue Eyes, page 64).

Image 3: I tried to make a strong visual impact with the use of the material, bringing the hands up above the head. This did not work because the elbows were too distracting. They went outside the cape/material line which broke the flow — or compositional triangle — and made the overall image too staggered. The straight hair and expression are too dominant and do not work within the triangle.

Image 4: The hands were brought down and placed in front of the model. A fan was positioned and turned-on from the left hand side. This created a windswept look which I felt was nearer my final aim. The hair was not quite blowing the way I wanted it to and the hands look clumsy and ungainly.

Workshop

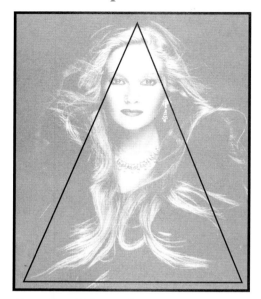

Compositional Rule: triangle.

TECHNICAL DATA

Model	• Louise	Toner	• Tetenal
Camera	• Hasselblad	Props	• Cape, black
Lens	• 80mm		gloves, Jewellry
Film	• Kodak T-Max, ISO 100	Extras	• Bowens Jet Stream
Background	• Lastolite		wind machine,
Lighting	• Elinchrom		
Paper	• Ilford MG RC/Agfa		
	Record Rapid		

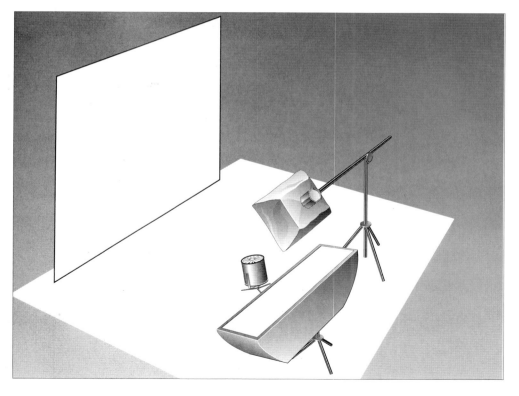

Lighting: The main light source was a small softbox positioned at a 45° angle and fairly close to the subject (Note that the smaller the distance between the light source and subject the harder the light).

A strip light was used to illuminate the subject from the bottom which also balanced the overhead lighting. To give texture and shape to the hair, a fan was positioned in front of the model. This combination of top and bottom lighting has added a vibrancy to the eyes and overall sparkle to the image.

Final Image (right): Printed on Agfa Record Rapid, selenium toned and then gold-toned to give it a subtle blue colour.

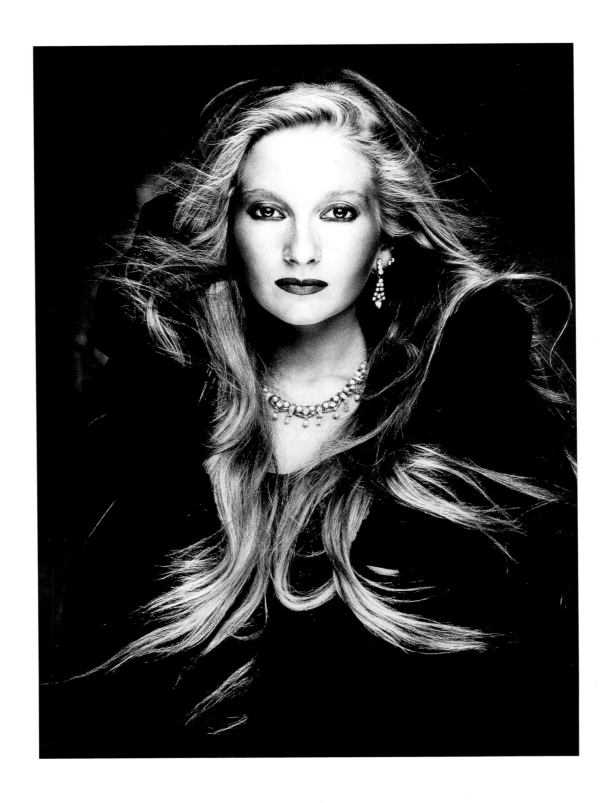

Louise

The Deep

The concept

I used to live close to the sea, so I suppose it is natural for me to be influenced by things to do with it. And because I am also interested in fantasy ideas, the idea of photographing a mermaid was bound to come up at some time or another!

But the story goes much further than the images shown here. The tail was specially made for me by a west country wetsuit manufacturer, who subsequently got in touch to ask me to do a commercial assignment for their catalogue (You can see some of the pictures I shot for those sessions on page 92).

This just goes to show that pursuing your own ideas can not only result in you broadening your scope of experience and contacts, but also create the opportunity to work for others – or even sell your work. It is therefore important that, during quiet times, you set yourself projects to fill the gaps. I make no apologies for the repetition in this book when I talk about the importance of experimenting – it is the only way to truly learn and understand the art of photography, and to develop your own style.

How it was done

The plan was to create the appearance of a mermaid relaxing at the bottom of the sea having just lured a passing ship. Although there is not much light on the seabed, I have used a little artistic license and just darkened off the background by burning-in during printing.

Cushions and a stool were arranged with a large fabric cloth thrown over the top. Props were then scattered around and the model posed. The first attempt (image 1) does not work because the tail is crumpled at its tip and the model's black gloves cause her right arm to disappear into the shadows. Not only that, but the rope she is lying on looks very messy and the body angle is too square to the camera.

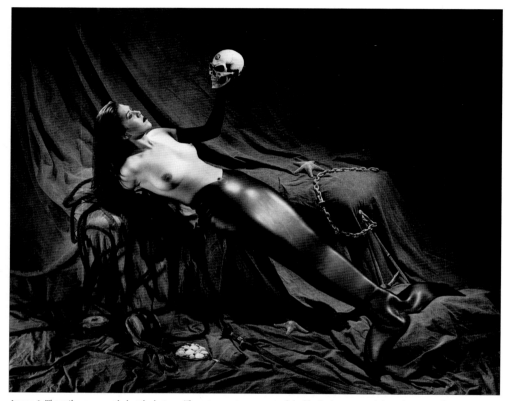

Image 1: The tail was crumpled at the bottom. The rope was too messy and the black gloves caused the right arm to disappear. The overall composition was too square.

In image 2, the camera angle has been taken higher to give the impression of looking down into the depths of the sea. I like the pose because it reminds me of a ship's figurehead, pointing the way forward from the bow. I also like the strong diagonal composition. Even so, the picture was not quite what I had in mind; there is too much space that would need heavy cropping during printing.

In image 3, the mermaid is preening herself, which makes for a more interesting image. It is a better angle (mid-way between the two earlier attempts) and still keeps the strong diagonal. Furthermore, the curves of the body are much more flattering than before.

The mirror has been adapted by sticking shells onto the reverse. The skulls and the sword give macabre touches.

Rather than give the picture a cold, blue tone – which would be the obvious choice because of the association with the sea – I decided to go for a rich bronze colour, by using a sepia toner, which I find gives the picture a warmer, golden and more timeless feel.

However, I still felt, after toning the print, that the picture needed extra impact, To achieve this I sandwiched a stock negative of the sea with the studio picture. This gave the effect of sunshine falling on a rippled sea bed.

Image 2: The angle of this image is now too diagonal and the subject is too rigid — mermaids are always portrayed as being curvy. Rather than start again, every possibility has to be exhausted, so it is very important to try different lenses and angles to achieve your ideal image.

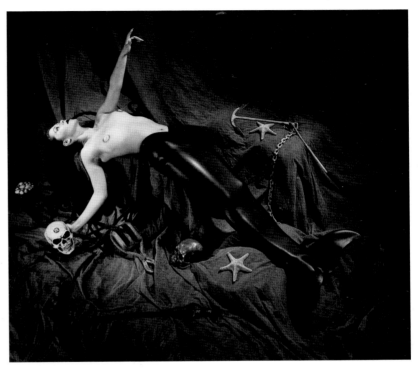

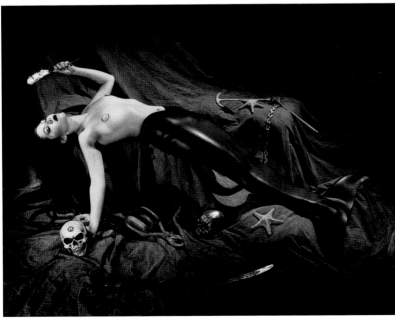

Image 3: I preferred this angle as it created a strong diagonal, complimented by the smooth curves of the body and the expression of contentment. The position of the arms balances the overall picture and also enables the use of props which add to the theme. Shells were glued onto the mirror and the use of two different coloured skulls was designed to show a difference in time.

Workshop

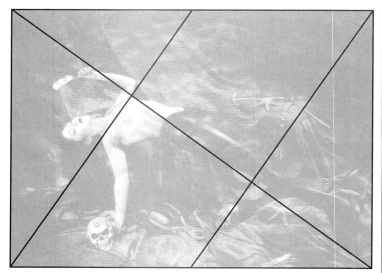

Compositional Rule: thirds.

TECHNICAL DATA

Model	• Correna	Toner	• Fotospeed
Camera	• Pentax 67	Props	• Mermaid
Lens	• 105mm		tail, stool,
Film	• Ilford FP4		cushions, skulls,
	Plus, ISO 125		starfish,
Background	• Omni USA		anchor, mirror,
Lighting	• Bowens		sword, netting
Paper	• Ilford MG FB		rope, pulleys

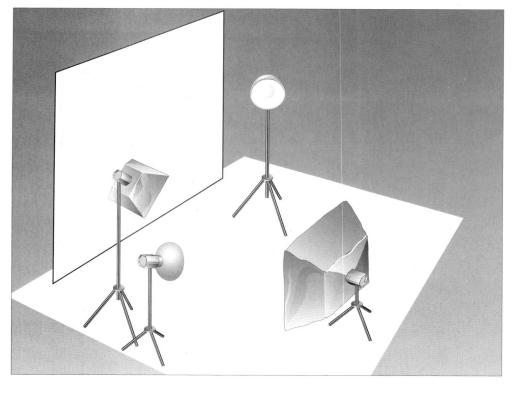

Lighting: Note the three different light sources used here. The fill I used gave a soft light and was large so as to cover the total area. The dishes were chosen to give specularity on the subject and the additional small softbox was chosen to illuminate the background and supply a small amount of fill/rim light on the subject. Otherwise, the fall-off from the front fill light would not have recorded enough of the detail immediately after the subject.

Final Image (right): The rich bronzy colour gives a feel of ancient timelessness and warmth.

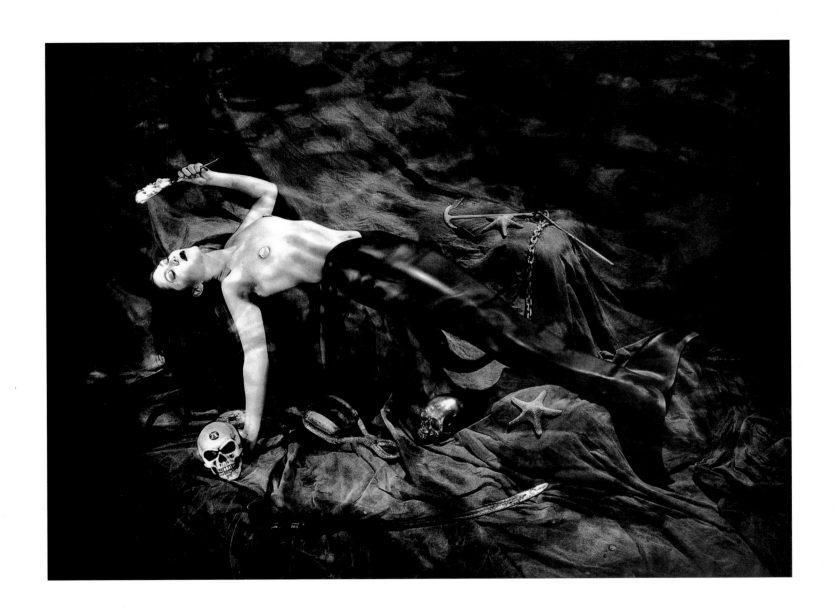

Simon & Correna

The concept

Another of my on-going projects, this time focusing on couples. I set myself quite a lot of themes like this because I find it is a good way of deciding on the types of pictures I will take. I can then come up with more exact ideas for each session. In this case, I wanted a Tarzan and Jane sort of picture, with the rope being a vine and the muslin serving as loin cloths. The intention was to create a steamy, sexual ambience using dramatic, theatrical body language.

How it was done

When working with a single model, poses can be tried under his or her own initiative, but couples have to be directed very specifically. Only the photographer can see the angles and know if one model is blocking the other. In order to prevent static poses, you can get the couple to move very slowly, as if in a slow dance.

Your own mood is also very important — it has to be in keeping with the picture you are trying to create. You cannot be rushing around immediately before the session; you have got to plan ahead.

Freedom of movement is essential for a picture like this. Therefore, I do not use tripods. You will be surprised how much difference it makes, how much easier it is to change the lens and move closer or further away. Also, I tend to use 220 film (double length rolls of 120 format) so that I interrupt the session as little as possible.

Image 1 is a good example of how one model can block the other; the male model's face and upper body are almost totally hidden. I like the female model's willing expression and the intimacy of the two models together, but I needed to correct the body blocking that had occurred.

As the session progressed, the poses seemed to become more sexually aggressive. That was not a bad thing, but there are several reasons why some of them did not work. In image 2, for example, Simon's right hand looks awkward and there are too many fingers gripping the rope. Also, the female model's head is too low, leaving a large gap to the left of the rope.

For me, the final print depicts the height of sexual pleasure. The couple are totally immersed in the moment. The female's head is positioned right back and there is total body contact. For a picture like this, the models have to be able to work well together, but the success of the picture really relies on the photographer carefully watching, and directing, what is going on. I keep looking at the heads and the hands and the overall pose of the bodies. You do not want to be worrying about your camera at this stage; the camera is secondary, it is what you are capturing that matters.

The patterned background, lit by a single spot, works well, giving a dappled look which I have fine-tuned by selective burning in and vignetting when printing.

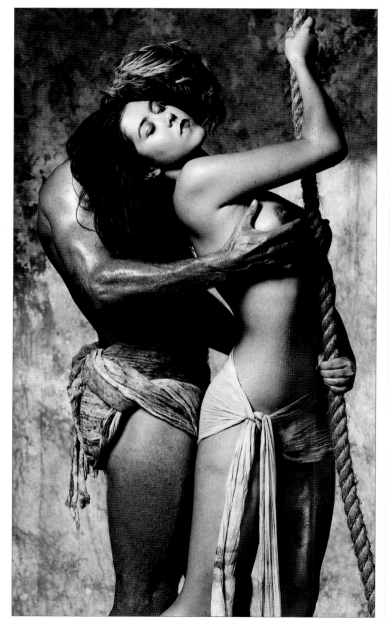

Image 1: The male model's head, tucked behind the female's, gives the impression of a gentle caress. The female's expression is willing. However, there is not enough masculine presence.

Image 2: The more the session progressed, the more sexually aggressive the poses became. Here the male's right hand appears awkward and the left hand, holding the rope with the female's, becomes confused because there are too many fingers. There is also too much space between the hands and the head of the male.

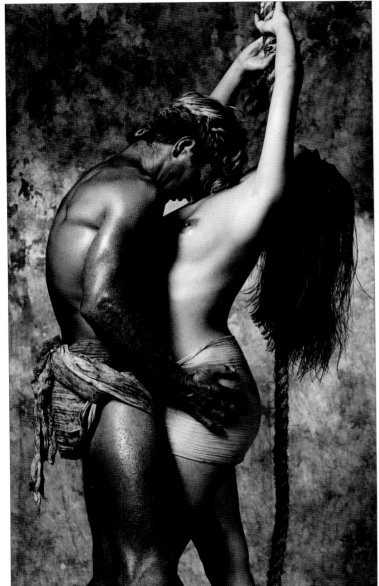

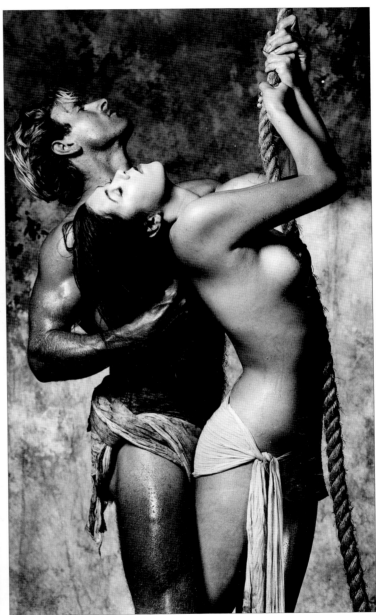

Image 3: The female's head, brought backwards, and the male's head, brought tight against the chest of the female, depict total togetherness.

Workshop

Compositional Rule: triangle with S & C shapes.

TECHNICAL DATA

Model	• Simon & Correna	Toner	• Fotospeed
Camera	• Pentax 67	Props	• Rope, muslin
Lens	• 105mm	Extras	• Lastolite Tri-Flector
Film	• Kodak Plus-X, ISO 125		
Background	• Omni USA		
Lighting	• Bowens		
Paper	• Ilford MG FB		

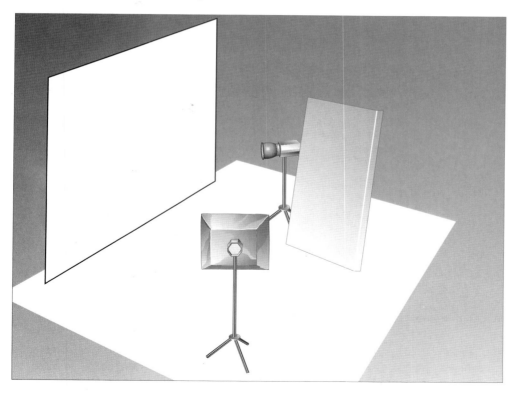

Lighting: *A softbox was positioned on the left-hand side, raised and tilted at a 45° angle towards the couple. The light from the softbox was bounced back via a large white polystyrene board.*
A focusing spotlight, slightly diffused, illuminates the background.
An option would be to have a Tri-Flector scooping spilled light from the softbox into the shadow areas at the bottom of the couple.

Final Image (right): This has been slightly vignetted all round to focus on the couple. Also, the print was burned-in slightly on some highlights, but not so as to flatten the image. It also helps to choose the correct grade of paper and brand; this comes from experience and experimentation and is very much influenced by personal choice. It was slightly bleached-back, in a weak bleach, and then sulphide-toned.

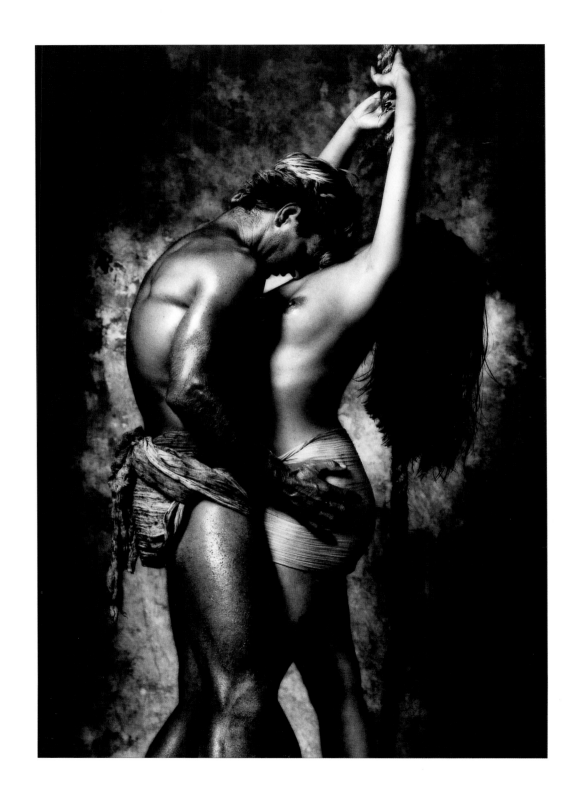

Simon & Correna

Renaissance Bride

The concept

The idea here was to create a biblical/Renaissance picture. Instead of using a male model, as is frequently done in the past, I used a female. This variation made it possible to give the image a slightly bridal look. It was quite an interesting picture to work on because the feel of the prints changed dramatically – from one of innocence to demonic overtones – as the idea progressed.

How it was done

I started off with a very simple, straight-forward, 'innocent' pose using a crown of thorns and skull as props (image 1). It is intended to portray both life and death – this was was my starting point. Although this first attempt works fairly well, on seeing the pose, I knew it was not quite what I wanted.

Adding the veil retained the perception of innocence and, in doing so, freed the expression to try other options. I chose to create a more demonic feel. The face is good here (image 2) and there is great eye contact, but the bottom half of the picture distracts from the rest; the fact that the model was bare-chested underneath the garland adds nothing to the overall effect.

In the darkroom, the negative was cropped to make the best of the picture. The garland now forms the bottom of the image and the bare skin that remains visible contributes to the feeling of innocence. Slight burning-in around the edges of the print helps focus the viewer's attention firmly within the picture.

I then added a cracked-paint effect (image 3) by placing a crackled screen over the paper and printing though it. Screens like this have to be as big as the printed area because they tend to show subtle, finer detail than is obtained when using a sandwiched screen in the negative carrier. In addition, the effect is constant when moving the enlarger up and down the column.

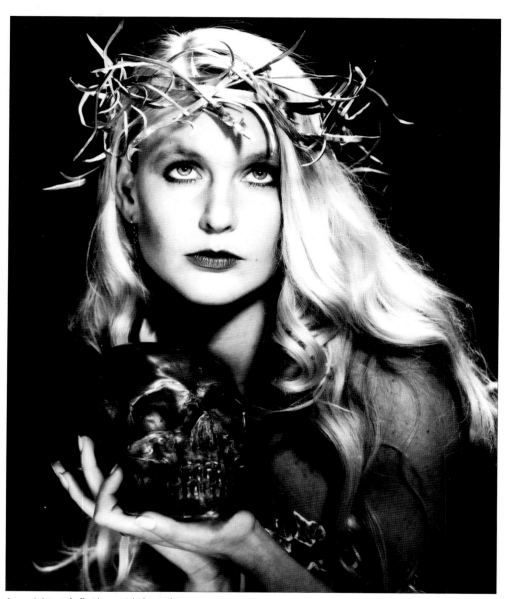

Image 1: I started off with a straight-forward, innocent pose using the crown of thorns and skull as props. The expression here was one of innocence, but not quite what I wanted, and the background was a little too stark.

Image 2: The position and expression of the model were changed for this image. However, a veil and garland were used to retain a look of innocence. The careful use of props can often portray a mood or theme better than an expression, thereby freeing the pose to further your final concept. More of the subject was photographed, than I knew would be used, to enable further control of cropping in the darkroom.

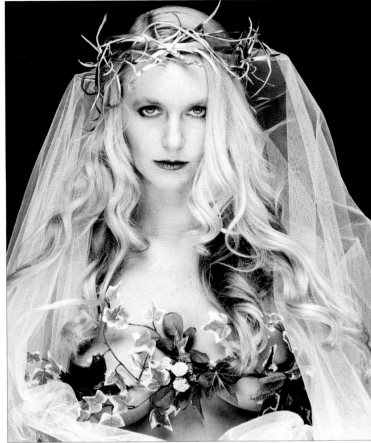

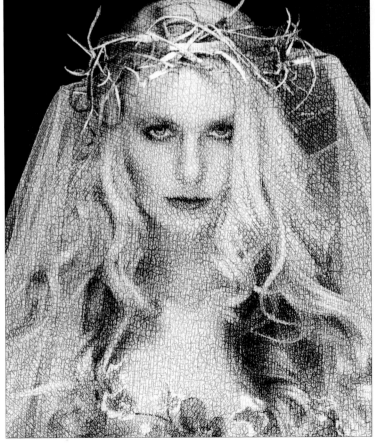

Image 3: A straight print showing the full effect of the crackled screen.

Workshop

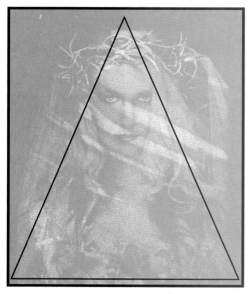

Compositional Rule: triangle.

TECHNICAL DATA

Model	• Phillipa	Paper	• Ilford MG FB
Camera	• Mamiya RB67	Toner	• Tetenal
Lens	• 140mm	Props	• Crown of thorns by
Film	• Ilford Pan-F Plus, ISO		English Arms & Armour,
	50		veil, garland
Background	• Lastolite black paper	Extras	• Printing Screen, Chrome
	Roll		reflector
Lighting	• Elinchrom		

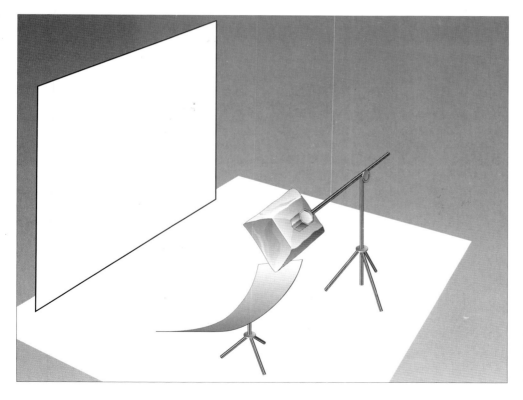

Lighting: *A small softbox was chosen and positioned near the subject to harden the light-source slightly. On some units, placing the light source fairly near the subject gives a natural vignette effect because the intensity of light has a central bias. A wafer softbox, or a soft-dish attachment, which has a diffuser in the centre gives an equal balance overall.*

Light from the softbox was also reflected from a chrome reflector into the model's eyes, balancing the overall lighting. Once again this shows how effective a simple lighting set-up is.

Final Image (right): This was blue-toned, placed in fixer and blue-toned again. A sponge dipped in sulphide was streaked over the final print. The eyes — windows to the soul — were bleached to improve viewer-eye contact. This treatment makes the final image more interesting and slightly more aggressive.

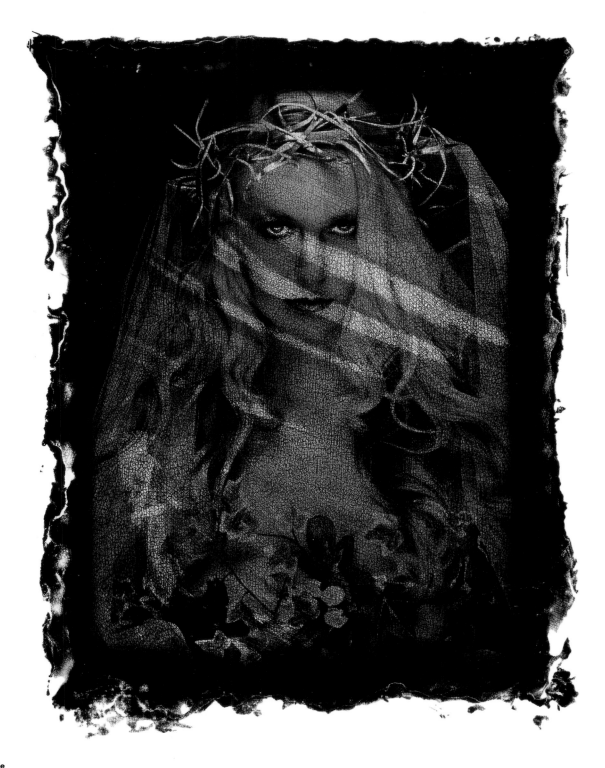

Renaissance Bride

Blue Eyes

The concept

This particular model has beautiful big eyes, so I wanted to draw the viewer's attention to them.

Care has to be taken on pictures such as this since tight framing, in most cases, tends to mean that not everything will be completely sharp. But there are exceptions. In general, it is okay to have ears out of focus, but not the nose – as was practiced by the 1920/30 Hollywood studio photographers. This is because out of focus images appear larger than sharp ones, so an out of focus nose will look bigger than normal.

A more dynamic pose is often one that puts the eyes on a slight tilt, rather than running horizontally across the picture. That said, the tilt can be very subtle, as it is here.

How it was done

The lighting was provided by a softbox reflected into a Beauty-Flector illuminating the face alone. An option would be to add a small 16° spotlight, set at half-a-stop extra exposure to hold attention on the face itself.

I tied a feather boa around the model's head. Best results are obtained when all the hair is tucked out of sight, leaving the face framed by the black features. To tie the boa, start with its mid-point on the front of the model's head, then pass the two ends down to cross and tie behind the back of the neck. The ends can then be brought forwards over the shoulders if required (as has been done here). Remember not to over-perfect the boa if it risks losing the model's expression!

My initial poses involved turning the head slightly to one side or the other. Although there is eye contact, the earring dominates the picture (image 1). With the squarer pose (image 2) the earring is less dominant and the picture more balanced. With the head angle dropped slightly (image 3) the whites of the eyes (canoes) become predominant making them the central focus of the picture – creating what I would describe as a more virtuous feel and the image I wanted.

During printing, the nose area was held back slightly to lighten it. Elsewhere, it was a deliberate ploy to lose detail in the blacks. The eyes were then tinted blue to make them the centre of attention. It is always the majority or minority of colour that catches the eye and, in the case of black & white prints, that usually means areas of spot colour.

When I am tinting prints such as this, I often (but not always) work on RC paper — usually glossy surface, Ilford or Agfa Multigrade. My technique is to have two prints, the best one and a close second, side-by-side. I mix the colours as needed, then apply them to the second print to assess the effect. The colours are then diluted or changed to get them just right before starting work on the

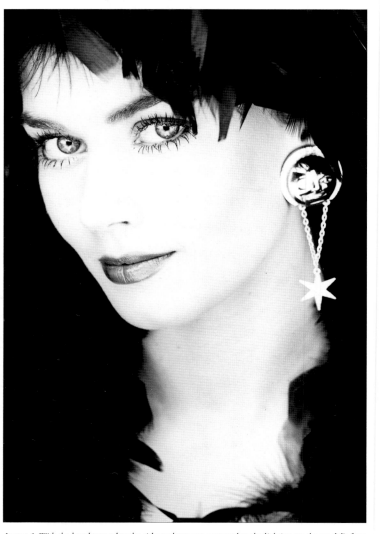

Image 1: With the head turned to the side we have eye contact but the lighting on the model's face is too broad. Also the earring is very distracting.

final print. Always have enough colour mixed for the whole area; you will never be able to mix more colour to exactly the same shade if you run out mid-way through the print.

Start light, and build-up slowly. The hardest thing is to eliminate the brush strokes — it just takes practice.

Image 2: The face is squarer to the camera, but the head is raised slightly too high and is too offset.

Image 3: The face is square on to the camera but is at a slight angle that allows the eyes to dominate the picture.

Workshop

Compositional Rule: straight thirds.

TECHNICAL DATA

Model	• Hannah	Tints	• Tetanal
Camera	• Mamiya RB67	Props	• Black feather
Lens	• 140mm		boa, earrings
Film	• Ilford Pan-F plus, ISO 50	Extras	• Beauty–Flector
Lighting	• Elinchrom		
Paper	• Iford MG RC		

Lighting: *This is a prime example of 'less is more' — one light with one reflector. I designed the Beauty-Flector, which unrolls and attaches to the softbox with velcro, to create a soft, even light — which is also relatively flat. This will therefore require more exposure regardless of film type or speed. As a rule of thumb, +1 stop should be sufficient if using the white diffuser on the softbox. Without the diffuser, normal exposure may be adequate.*

Final Image (right): This image was printed on Ilford RC glossy paper and the eyes were hand-tinted with blue photo-dye.

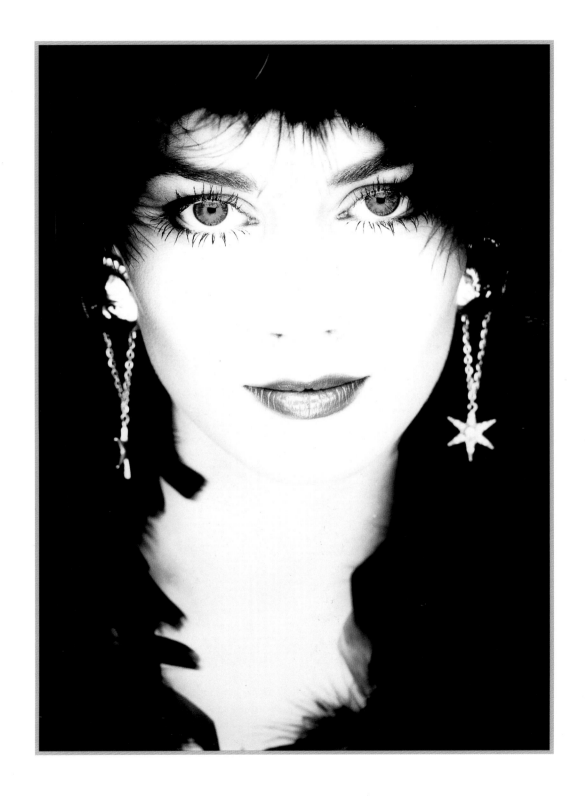

Prince Charming

The concept

Another of my fairytale pictures shot on Ilford Delta 100 roll-film. This one is my perception of *Prince Charming*. I have always thought of princes as being a bit wicked, like naughty children, and also very feminine — perhaps because they are nearly always played by women in pantomimes. For the pose, I imagined the Prince passing a line-up of his subjects, on entering a hall, where a royal banquet was taking place. The three expressions shown here reflect my perception of the relationship with the person with whom the Prince has eye contact – the message in all three is very different.

I have put these elements together here: the horns, the female model and the feather-covered ball mask. To reinforce the pretend aspect of the picture, I used a velvet sheet as clothing, leaving the rough edge visible to prove that things are not quite what they seem.

How it was done

The hair was a wig bought especially for the shoot. The horns were also purchased for the occasion. Both are now in my props drawer for future use in other pictures. The mask came out of that very drawer and was already seven or eight years old, but had only been used twice before. It is not always necessary to spend huge amounts of money where imagination will do; these props were relatively inexpensive.

I started off with a demure pose giving a shy, slightly coy look (image 1). This definitely works but, because it is too subtle, it does not hold our attention. I want people to react to my pictures and I do not think that this one fits the bill.

Keeping the pose exactly the same, I got the model to turn her eyes towards the camera (image 2). Her head angle has hardly moved at all, yet the picture is very different. I then went for a more lively look, with the model's mouth open and her tongue sticking out (image 3). Once more, this is very different and I must admit that I had difficulty deciding which of these two pictures was my favourite.

As I have said earlier the way that I work is to print all the most successful shots, then to leave them out for a period of time to see how I feel about them. Even in just a few days, it becomes apparent which one works the best. But the instant favourite may not last; sometimes the best one grows on you. That was very much the case here. The more lively look became uncomfortable and did not have as much staying power. Also, I did not really like the elbow being so close to the waist-band. In the other picture, there is more space.

As with *Beauty And The Beast* (page 32), I used a rough border effect to enhance the picture – as well as a textured screen. I also printed the picture softer and darker than I would normally, then bleached the image back to give it an antique look.

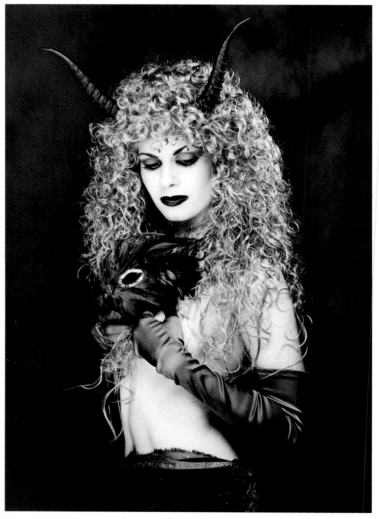

Image 1: This demure expression would have worked but I felt that eye-contact was necessary to capture the imagination of what the model was looking at or feeling.

Unlike many of my pictures, I did not light the background separately and it has, therefore, recorded rather dark. When I was working on my initial prints, one of the things that I varied was the background density. For the final print, I lightened the background considerably, dodging it while printing.

As I have said before, subtle lighting effects are often far easier to imitate (and vary) under the enlarger than they are in the studio.

Image 3: Eye-contact gives the impression of a passing glance from the Prince walking into a room. The elbow is slightly higher, exposing more of the waistline.

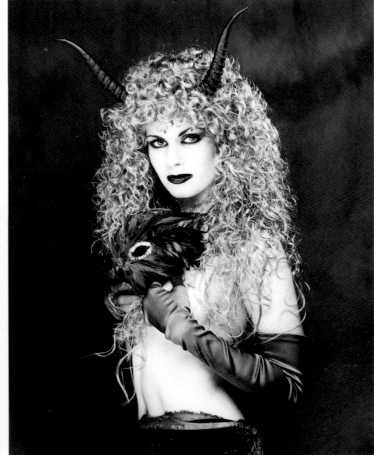

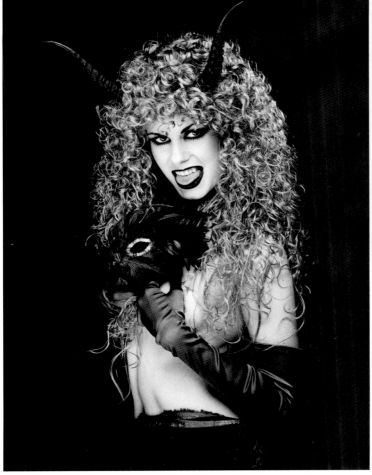

Image 2: This pose is basically the same as the above, so the choice was between this image and that of image 3. The tongue is effective but becomes uncomfortable. After viewing the image for a time, it loses power. The left elbow is too near the hip and not enough waistline is showing.

Workshop

Compositional Rule: thirds.

TECHNICAL DATA

Model	• Jo	Toner	• Fotospeed
Camera	• Pentax 67	Props	• Velvet fabric,
Lens	• 105mm		gloves, horns,
Film	• Ilford Delta 100		mask
Background	• Lastolite	Extras	• Chrome reflector
Lighting	• Bowens		
Paper	• Ilford MG FB		

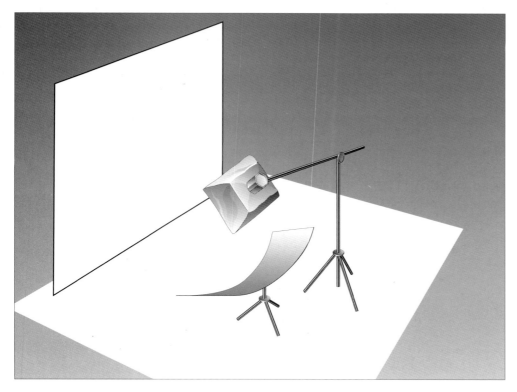

Lighting: *This was kept very simple. A softbox was mounted on a boom and angled at a 45° angle towards the subject. A chrome reflector was placed below waist level, which bounced light back from the overhead softbox into the facial area of the model to help lift the definition.*
A further option would be to use strip-light in place of the reflector.
A background light was purposely not used as all I required was a small amount of detail, which was achieved via spill from the main light.

Final Image (right): The image was exposed through a screen placed on the photographic paper, again to give it a cracked, old feel. To further enhance the aged and antique look I printed it on a soft grade, and bleached the image back.

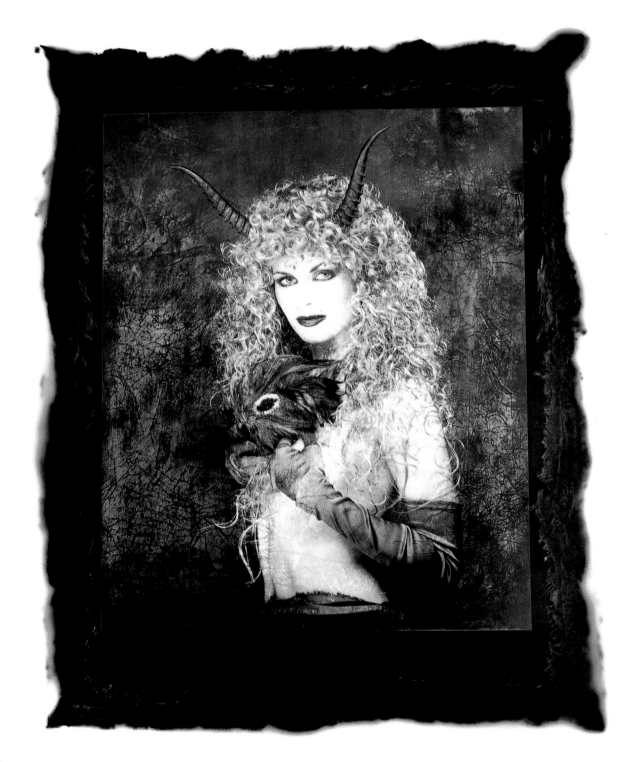

Prince Charming

Divine Light

The concept

It does not really matter where the inspiration for your pictures comes from. In this case, it was the idea of a 'Divine Light'. I wanted something spiritual showing purity and, at the same time, venerability.

The bird of prey, the virtually naked model and the graveyard location all strengthen the spiritual concept. It was important to take the picture with the correct lighting so that the model's face could be properly lit. I also wanted a soft light, so a sunny day would not have been suitable. In the end this image was shot late in the afternoon of a bright, but overcast day.

How it was done

I chose this particular tombstone because it was overgrown and had a cross on top. The lighting was entirely natural. To visualise how the scene would look in black & white, I viewed it through a deep-red filter which took away the colour and revealed the strength of the shadows and highlights.

Another useful tip, for bright and overcast days, is to use the trunk of a tree to see which direction the light is coming from. Looking for the brightest side of the tree trunk is much easier than looking at the ground and trying to decide which way the shadows are falling.

There was not much to do with the various elements of this picture because I had planned what I wanted in good detail before we started. The only variation I used was having the stuffed buzzard held either high up or low down. In the higher position (image 1), it looks a bit like a parrot on the shoulder, so obviously that was not right. Lower down, the buzzard is much more effective and that is how I felt it should be.

In the darkroom, I experimented with dodging-out a shaft of light – the intended effect was supposed to look like a beam from heaven (image 2). I tried dodging for between 25% and 75% of the exposure time until I got what I thought was right. In the black & white version of the dodged image, you can see that the shaft of light competes with other bright areas in the sky and the distant background.

To do the toning, I started off testing a darker than usual print to see if I could play-down the bright areas. The results of a toning test print, showed that this was not the correct solution to the problem. So what I did was to make a bright print (with darkened edges) and toned it as usual. I then retouched the bright areas at the bottom of the image using diluted photo-dyes. The result is a slightly smoky look that, I think, works particularly well.

Although my test prints are all on 10 x 12" paper, I do not do all the manipulation on these small sizes. Instead, I mainly print on 16 x 20" — the size of my final pictures. On average, it can take many attempts to get the image right. I will then do four final prints. One is used for toning and/or colouring

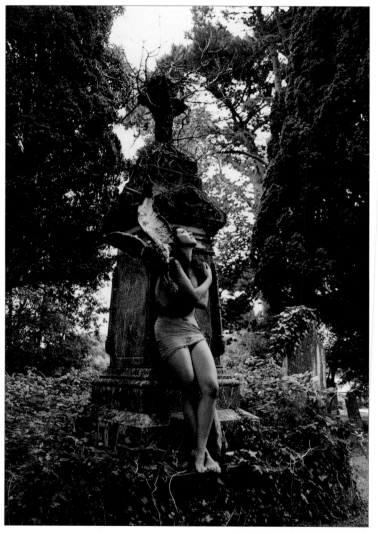

Image 1: The position of the bird is wrong in this version. It is not only hiding part of the head it is also lit incorrectly. The direction of light is from the top-right of the image and is coming from a gap in the trees. It had just started to drizzle so there was not a lot of time to experiment.

(with a second best print used for testing), another is kept as-printed and at least one is put aside for safety in case anything happens to the other two. Once I have printed a negative the way I want it, I rarely go back to it again because I am always working on new pictures.

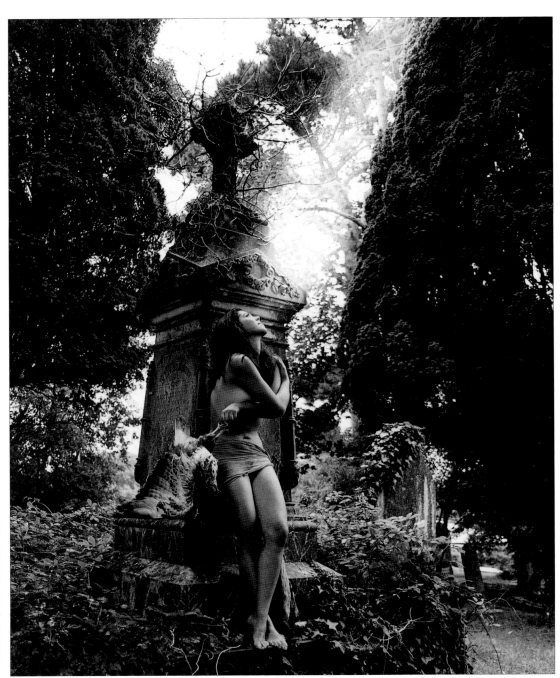

Image 2: By lowering the position of the bird, the space around the model is freed and the lighting on the buzzard is less important. It also means the bird becomes part of the overall diagonal composition of the image. In the darkroom, part of the image area was held back under the enlarger, using a home-made dodging tool, to create an impression of a shaft of light which becomes part of the dynamic diagonal.

Divine Light

Workshop

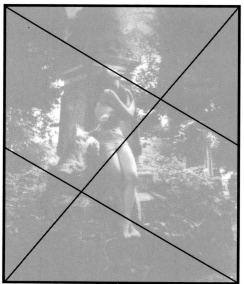

Compositional Rule: thirds.

TECHNICAL DATA

Model	• Correna	Props	• Stuffed
Camera	• Pentax 67		buzzard,
Lens	• 150mm		muslin
Film	• Kodak Plus-X, ISO 125	Also:	• Print dodged
Lighting	• Natural		to create the
	daylight		illusion of a shaft
Paper	• Ilford MG FB		of light
Toner	• Tetenal		

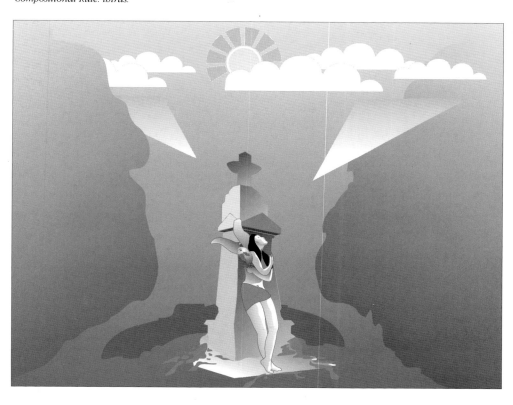

Lighting: As a general guideline when photographing outdoors, one thing I try to look for is the same quality of light as I would use in the studio. For this purpose 'raw' sunlight is equal to bare bulb flash and bright overcast days represent diffused light, of varying degrees.

The environment can also offer other variations such as, light reflected off walls and shaded areas around trees. The time of day will have a dramatic effect upon available light quality. The angle of the sun the first few hours in the morning and the last few hours in the evening are similar to the angle of lighting we normally use in the studio if shooting 'classical' images.

Final Image (right): I decided to sandwich a stock negative — of thunder clouds to lower the brightness, and increase the drama, in the top-half of the image — with the negative shown in image 2. The shaft of light was created in the same way as before and the print sepia-toned.

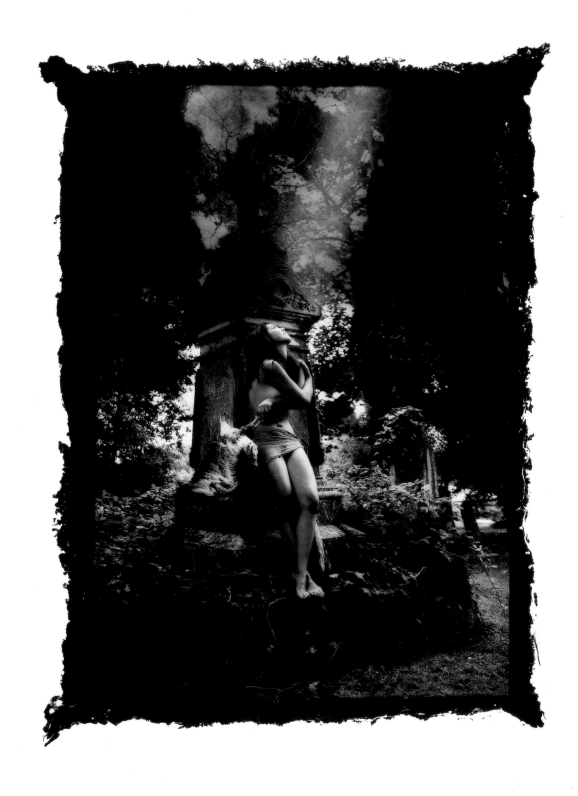

Divine Light

Tanya

The concept

This girl came into my studio one day and asked me if I would do some topless pictures for her to give to her boyfriend as a present. She had bought lingerie with her and, although the resulting images worked well, I thought they were stereotypical. I knew I could do something better in my style that would emphasise her sensual curves simply, be equally appealing and suggestive. It is often what you do not see in these types of pictures that makes them work better.

How it was done

If you look at *The Venetian* (page 88), you will notice that it features the same background, except that here I used mostly the bottom half of it. You will also see the crown in other pictures, such as *Renaissance Bride* (page 60).

Having the arm across and around the top of the model's head (image 1) portrays a feeling of despair, as opposed to the position in the final image that is more sensual. Both prints work but, for the purposes of this shoot, it was the latter one that I envisaged as being more applicable. This is a good illustration of how a simple movement, or gesture, changes a picture's character.

The leg nearest the camera is the posing leg. Although there is a nice curve to this, I felt that the composition of the image benefited more from the posing leg being lowered. Having done this, I then asked Tanya to wrap muslin across her chest. I also decided to try bringing both arms up to her head (image 2). Unfortunately, this made the rib cage protrude, so that idea was not going to work either.

In image 3, I went back to having one arm raised, but turned it so that the shape echoed the model's left leg and the overall form of her body. There is a good S-shape to the pose, which now flows much better. You will notice the light intruding into the picture on the right. I did not worry about this because I knew I would be able to crop it out

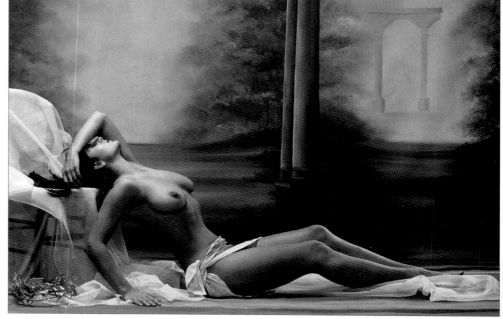

Image 1: The position of the model's arm over her face is too clumsy and looks too small in context with the rest of the body. The image is sensual but it is not necessary to show the breast — it looks too much like a gratuitous gesture rather than something that compliments the pose.

during the final printing. If you look at the top right-hand corner of image 2, you will also notice the backdrop. This reinforces what I said about the size of the background, rather than the size of the studio, limiting the kind of pictures you can take.

As well as cropping the final image to give a more elongated format, I also used a piece of black silk stocking under the enlarger lens to diffuse the image. Whereas softening over the camera lens bleeds highlights into shadows and makes the highlights glow, softening under the enlarger bleeds the shadows into the highlights, giving a more intimate feel to the picture. The final touch was provided by sepia toning.

Despite all the refinements made at the printing stage, the key to this picture is the fill-in light that came from a large softbox just below the camera.

Too much fill, would make the picture look flat; too little and it would be lacking shadow detail. The fill-in used here was about two stops below the main lights. A good experiment is to take some pictures with just the fill-in light switched on — the negatives should come out under-exposed and flat. Compare this with a shot taken by the main lights only. If you like, do a series of tests, setting the fill-in to different levels and see how the final pictures turn out.

I am deliberately not giving lens aperture and lighting power settings because these only make sense for my lights in my studio. It is more important to look at what I have done and make your own interpretations. When I take inspiration from other photographers' work, I do not telephone them to ask exactly how they took their pictures; I experiment and make reference notes.

Image 2: Wanting a more comfortable overall image, I asked the model to move her arm. The addition of muslin, to conceal the bust, creates a sense of mystery. The only problems here were the predominance of the ribs and the underarm

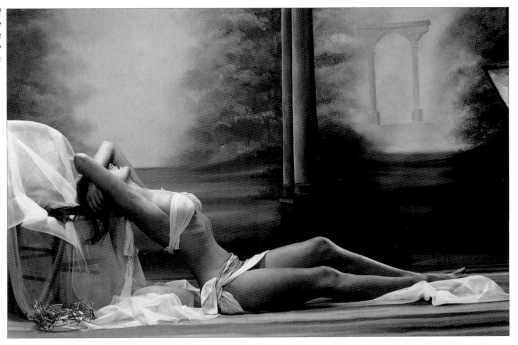

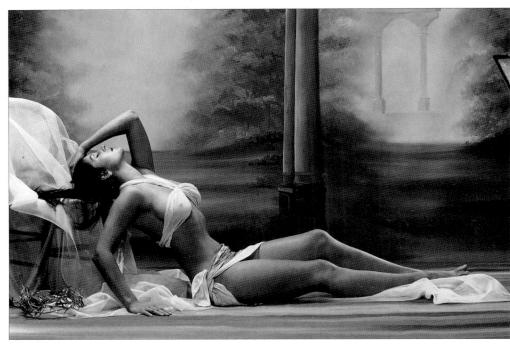

Image 3: The extra muslin improves the picture and the lowered right arm enhances the line of flow. The left arm position frames the face and also contributes to the symmetry of the pose.

Tanya

Workshop

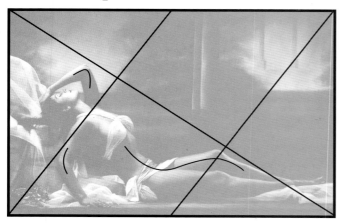

Compositional Rule: thirds and S & C shapes.

TECHNICAL DATA

Model	• Tanya	Lighting	• Elinchrom
Camera	• Mamiya RB67	Paper	• Ilford MG FB
Lens	• 90mm	Toner	• Tetenal
Film	• Ilford Pan-F Plus,	Props	• Muslin, crown,
	ISO 50		chair
Background	• Colorama		
	scenic		

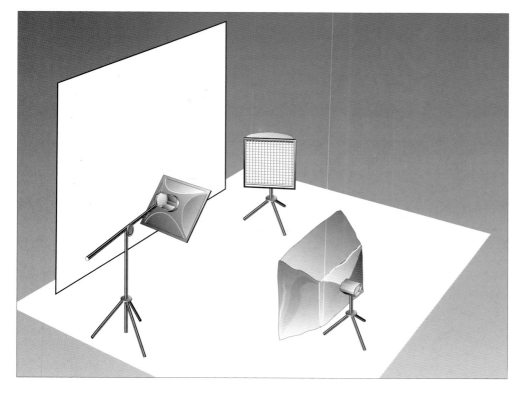

Lighting: *This set-up is slightly more complicated than I would normally use. The key to this picture is the fill-light light, without which there would be no shadow detail. So my choice was to use a large softbox, square-on to the subject, which illuminated the whole area. I then proceeded to light the top half of the model with a 44 x 44, angled at 45°; this light 'skimmed' across from the head to the knees creating natural fall-off.*
A kick-light was positioned in the far right-hand corner to highlight the bottom section of the legs.
The use of Polaroids was crucial to balancing the lights.

Final Image (right): This was cropped to strengthen and lengthen the pose. Selective burning-in on the muslin and netting was done in the darkroom. Finally, the print was sepia-toned.

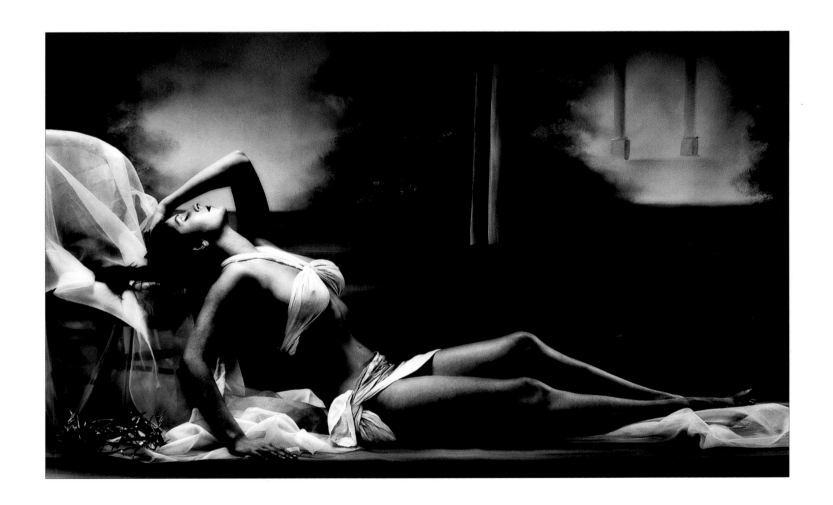

Tanya

Eve

The concept

I shot this picture for the cover of a bridal magazine. It was taken in a derelict church. The roof had vanished many years previously, giving plenty of light from above and making this a rather unusual sort of interior picture.

I quite often drive around photographing potential locations and then process the pictures, and mark their position on a reference map. This is a useful habit to develop, because even though a location may not be needed at the time, it is very useful to develop a database of potential sites for future work.

How it was done

Because this was a commissioned picture, I enjoyed the luxury of having the bouquet made and the wedding dress specially chosen. I had photographed the girl many years before, when she first got interested in modelling. She has since gone on to be photographed by Helmut Newton, amongst others.

The church is down by The Lizzard in the West Country. The local's complain that the church has fallen into disrepair, but I think it has a beauty all of its own.

The magazine I was working for did not question the location because they wanted something a bit different. I used only natural light, with the walls of the church providing most of the fill. To brighten the model very slightly, I used a collapsible Lastolite reflector to throw just a little light up from below.

The window was a convenient frame for the picture and it also provided a wide sill for the model to sit on using a classical side-saddle style. The first pose was a bit stiff (image 1). The model's left arm is too straight and the line of the dress too hard. Also, her head clashed with the window column.

The second attempt (image 3) relaxed all the lines slightly, but made the pose too square-on to

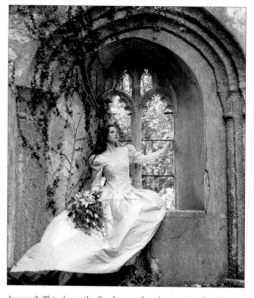

Image 1: The arm holding the bouquet is too straight and the head clashes with the central column of the window.

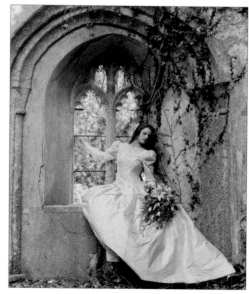

Image 2: This shows the final pose after the negative has been flipped. It 'reads' much easier.

the camera. Nevertheless, just by turning the model's head slightly to her right (keeping the nose within the cheek line) the picture was much improved (image 4).

In fact, the only differences between the second and third prints are the change of the head angle and the slight movement of the dress caused by a gust of wind. (Look carefully, and you will see that the bottom of the hem has blurred slightly).

Bearing in mind that the picture was to be used on a magazine cover, and that western people 'read' pictures left-to-right, I decided to flip the negative when I printed it (image 2). You can see how much difference this makes, even without any other printing improvements, by comparing the straight b&w pictures. Already, the image is well balanced and has a timeless elegance.

To make the image stronger, I vignetted the print to hold attention within the centre of the picture, then hand-tinted the bouquet.

Image 3: Although turning the head to follow the line of the dress is another option, lighting the side of the face in the shadows would prove difficult.

Image 3: The left arm holding the bouquet is now correct and the head needs to be positioned better to compliment the flow of the dress. Also, the right hand is a little bit too square to the camera.

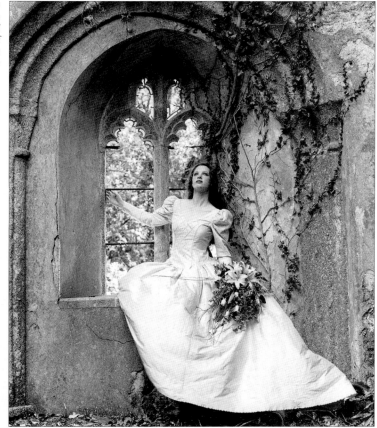

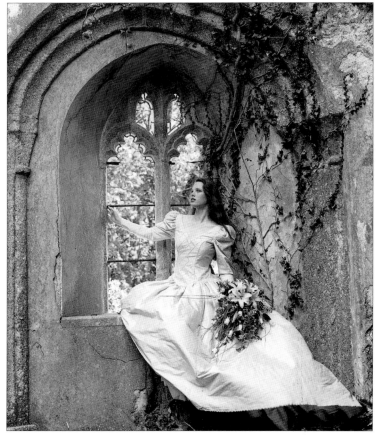

Image 4: Having repositioned the head to give a more elegant flow to the picture, (the nose is kept within the cheek line) the hand has been moved to more or less a 45° angle.

Workshop

Compositional Rule: triangle and thirds.

TECHNICAL DATA

Model	• Eve	Props	• Wedding dress,
Camera	• Mamiya RB67		bouquet
Lens	• 90mm	Extras	• Lastolite disc reflector
Film	• Ilford FP4 Plus, ISO 125		
Background	• Location		
Lighting	• Natural daylight		
Paper	• Agfa Multicontrast FB		
Toner	• Fotospeed		

Lighting: *What you have to imagine is the model sitting on a window sill surrounded by four walls and no roof. Opposite the model was a bright limestone wall that acted as a fill-in light – the sun was high in the sky but obscured by clouds, giving a beautiful soft lighting effect. To add sparkle to the models face, a small disc reflector was used to direct light onto it. The back-lighting on the dress was about half a stop brighter. This resulted in a nice rim-effect.*

Final Image (right): The print was selectively darkened and selenium-toned, whilst the bouquet was hand-tinted using photo-dyes.

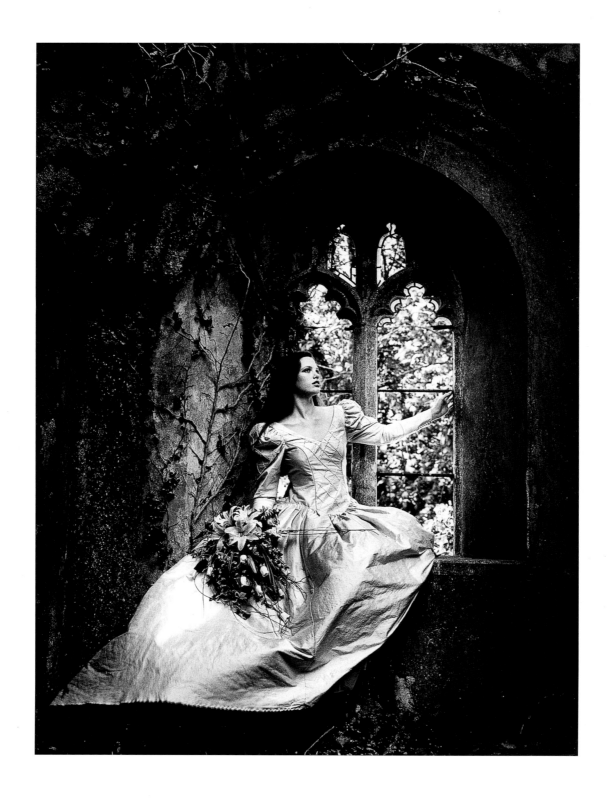

Eve

Ephesus

The concept

I wanted this statuesque picture to have the feel of something from Roman mythology. It was shot late one afternoon at a disused Cornish tin mine (the walls of which provided privacy).

How it was done

Although I normally add softness under the enlarger, this picture was taken using a soft-focus camera lens. Nothing else but natural light and a single reflector board was used for this picture. I took along a flashgun to add fill-in light, but I did not need it on this occasion.

Working outdoors relies on finding the right locations. That includes knowing how far it is from the nearest car access and also how many other people might wander by. It was very important to pick the right time for this picture — I chose the end of a summer's day which gave the correct angle of soft light from the sun. The plinth contributes towards suggesting that the model is a statue and the dramatic sky adds to the atmosphere. .

I had some problems getting the right arrangement of the model's body, also the fabric was blowing around in the wind. So, once we got the poses, we had to work quickly. In image 1, there was too much muslin at the front of the picture and the model's hand cut across the skyline. Also, her tattoo ruined any claim to classical mythology! Hiding the tattoo and sweeping the muslin backwards gives a much better result (image 2). I also moved the sword back, which made it disappear into shadow. The left arm does not have enough muslin around it. The final pose used a more delicate grip on the sword and raised the head directly up to the sky (image 3).

I shot this picture in 1989. I would certainly make it neater today because my design sense has improved. Most importantly, the sword's point would be nearer to the model's foot to give a stronger composition. But what I am able to do, even now, is to crop the negative at the sides to make the picture look more slender. Not only does this emphasise the model's body height, it also forces the viewer to look up and down the picture. Another advantage of the slimmer crop is that the muslin reinforces the diagonal structure of the image, which it did not do previously. Having re-framed the print, I burned-in the sword, the muslin and the sky, and also darkened all the edges before toning.

In general, bright areas tend to attract attention, as do coloured areas. This picture has both elements — bright areas of muslin and the sword, with coloured areas of the skin, background and sky. This could cause conflict, but here it works in harmony. Without doubt, it is the flow of the muslin that holds everything together.

As with most images it is possible to take this one further and should always be a consideration as you approach printing the final version. In this case, an idea

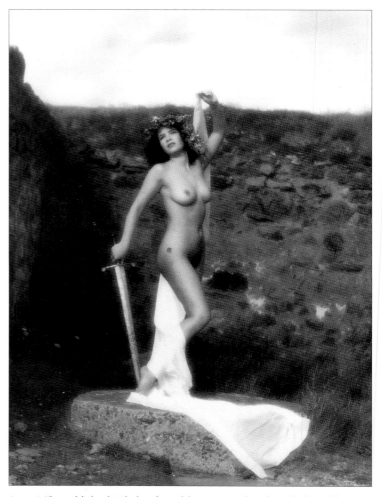

Image 1: The model's head is tilted too far and there is too much muslin at the front of the picture. Also, the model's foot looks uncomfortable. The tattoo on the thigh is distracting and not true to the concept. The left hand is cutting through the skyline, but I prefer the angle of the sword and arm in this picture to that of the final image.

would be to blend in a Greek or Roman ruin in place of the sky, or within the sky, by using a sandwich negative. This raises the question, when is a print really finished? Obviously, this is subjective, but there is no reason why you cannot have two or three different versions of a particular print – eventually, one will come to the fore as the main image. It is through these methods of experimentation and crtical analysis that we become better photographers.

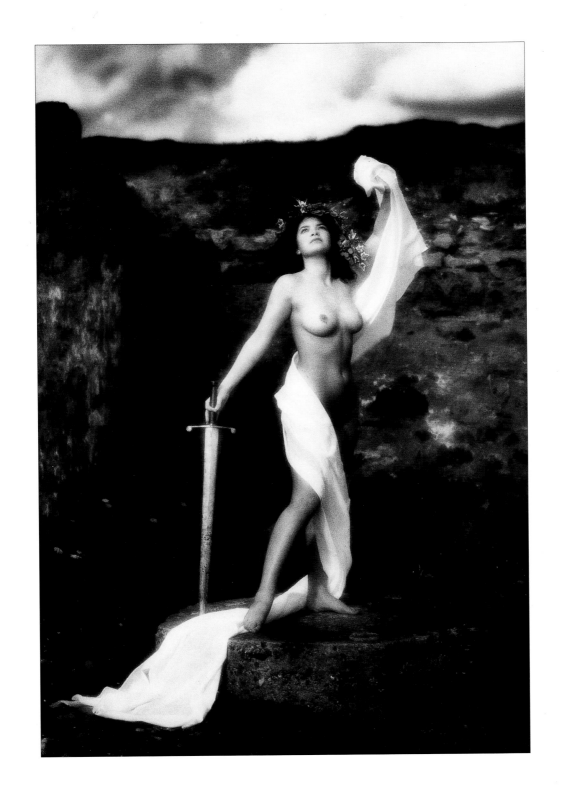

Ephesus

The Venetian

The concept

I had made a similar picture previously, in which the model was topless. I wanted to achieve a more classical result suggesting that the person in the picture was a wealthy Venetian woman.

Coming back to your own ideas is like taking inspiration from other places — it gives you a chance to improve on what has gone before. As it happened, this picture developed far beyond my original concept.

How it was done

A length of velvet was twisted and draped around the model to provide the hooded effect. The velvet was tied in a similar way to a feather boa — looped over the head, crossed over and with the ends tucked out of sight.

The star on the top of the head-dress was actually an earring, pinned onto the material to break up the mass of black fabric. Lace served a similar purpose at the bottom of the picture and added a feminine touch. The make-up was particularly dark.

Holding detail in the black velvet without burning-out the highlights was only possible by very careful film exposure and development. As a rule of thumb, expose the black & white film for shadows and develop for highlights. In this respect, different films have different characteristics. These differences are often only thought of in terms of grain and sharpness, but for a picture like this, tonal range is the most important thing. It is very important to experiment and keep notes.

I started with an upright composition (image 1). The biggest problem with this is that there was too little velvet for a vertical framing. Either the lace had to be burned-in darker, or the negative would need to be heavily cropped. But even if one of these remedies had been used, there would still be too much space, around the face, inside the fabric loop. There was also another problem — too much

white under the pupils of the eyes. I have mentioned before about trying to get 'canoes' in the eyes, and also what happens if you go too far — this is a classic example and it is not a flattering look.

Switching to a landscape composition (image 2) immediately removed the need to crop the bottom of the picture. The head was repositioned, giving a much better look.

When I saw this picture, I realised that the column divided the picture in two, and that the right hand side was empty, as if something was missing. I then had the idea of combining two pictures together, putting two different views of the model on opposite sides of the column.

With this in mind, I shot another variation. This time, the velvet was slightly repositioned, closing the gap between the head and the background. I particularly like the tilt of the head and the eye contact in this shot. I was not too worried about the lace at the bottom of the picture any more because I had decided that I would be using a panoramic format to create the double-image print.

You can see how this started to come together as soon as I printed the tighter crop (image 3). I knew that, if I matched the column from the centre, I would have a perfect blend for the double image. Care has to be taken to avoid the presence of a blending line through the image centre.

Marks on the easel blades identified the position of the blend line, allowing me to print one half of the picture (with the other half of the paper covered), then to flip the negative and print the second half, whilst covering the exposed first half.

I always do prints like this, one at a time. The obvious way is to do several first halves at once, but I am impatient and want to get a result immediately. And, if I get it right first time, I will not have wasted my time doing half-prints that I do not need.

One very important accessory when doing this sort of printing is a red safelight filter that can be swung under the enlarger lens. With this in place,

Image 1: This image started as a vertical shot. There was not enough velvet material to cover the lace which would have, therefore, needed cropping or burning-in. The model's head was tilted towards the column to give the desired effect. With drastic cropping, a reasonable finished image could have been achieved, but the distraction of lace and skin in the middle of the velvet, to the right of the picture, showing the tip of the shoulder, made me select another image from the shoot.

you can frame the second half of the picture, aligning the middle of the column along the blend line, then place the mask in exactly the right place to cover the other half of the paper.

This is another example of the importance of discovering different techniques as we progress with our photographic methodology. This image shows how using new ideas with old concepts can sometimes result in a better photograph — which proves the point that what we may think to be the best image initially, may sometimes be lacking in a technique or skill yet to be discovered.

Image 2: This landscape shot was the correct shape. The velvet material was rearranged on the shoulder to conceal the lace. I particularly like the eye-contact and the tilt of the model's head. Also, the closed gap between the right-hand side of the model's neck and the velvet makes the viewer concentrate on the model's face.

Image 3: This tighter crop illustrates the strength of the column as a potential blending line for a double image.

Workshop

Compositional Rule: two triangles with diamond impact points.

TECHNICAL DATA

Model	• Jo	Paper	• Agfa
Camera	• Pentax 67		Multicontrast RC
Lens	• 105mm	Toner	• Fotospeed
Film	• Kodak Plus-	Props	• Black velvet
	X, ISO 125		fabric, black
Background	• Colorama		lace, jewellery
Lighting	• Bowens		

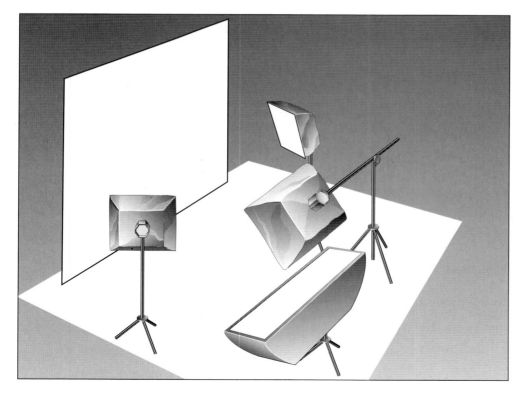

Lighting: *Two small softboxes illuminated the background. One large softbox lit the subject at a 45° angle. A strip-light was used instead of a reflector. This gave a bright long catch-light in the model's eyes.*

An option would have been to move both lights slightly clockwise to create more shadow detail on the cheek and chin, reminiscent of a classical style of lighting. Instead of moving the lights to create shadow I used makeup on the cheeks.

Final Image (right): This image lent itself perfectly to reversing and blending. I toned this blue and as a final touch could have bleached the whites of the eyes with Farmers Reducer or coloured them with a photo-dye. On this occasion I decided not to.

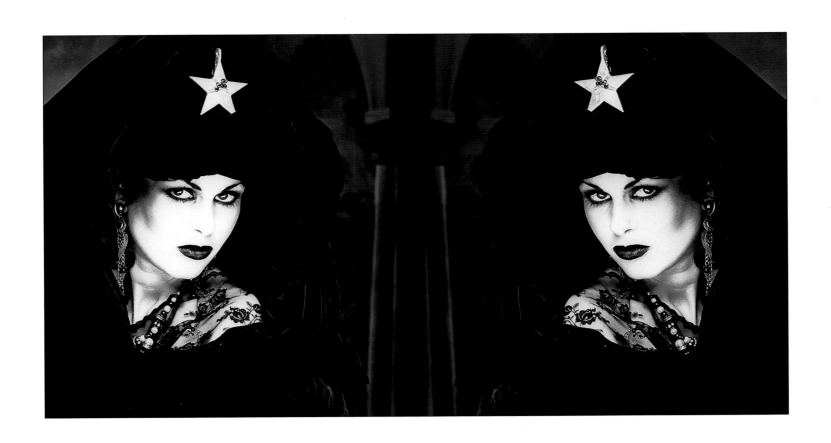

Terminator

The concept

In many respects, these pictures are the culmination of everything that has gone before in this book. You will be able to spot compositions, poses, props and models that have already been used.

Once you have focused on a theme — in this case dictated by the wetsuit name (Terminator, Predator, etc.) you have to reflect this in the image content. The collection of images shown here illustrate what is possible from one properly planned session and even here there is a new technique being demonstrated.

How it was done

One of the problems with the picture of the mermaid's tail hanging down from above (image 5) is the lighting. As you can see from the reflections in the shiny rubber, softboxes were used for that picture, giving small highlights.

In contrast, the over-the-shoulder version (image 6) was lit with an overhead soft box and a strip-light to the right of the model which gave longer, narrower highlights that are more flattering to the rubber. The star-burst effect that I used in the picture was created after the final print was done — it would be impossible to do otherwise.

What I did was to print the picture as I would normally, making a toned 16 × 20in final image. I then punched a small hole through the print and put a light on the other side. A large sheet of black card was positioned behind the print, with a cut-out that coincided with the punched hole.

The purpose of the card was to stop light shining through the print as a whole (causing a loss of image contrast.) By fitting a star-burst filter over the camera lens and shooting the print onto colour slide film, I was able to achieve the effect I wanted, but only as a copy transparency; there is obviously no original photographic print of the star-burst image.

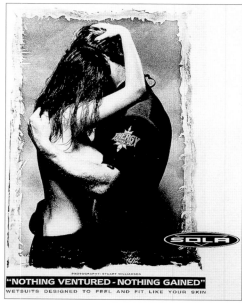
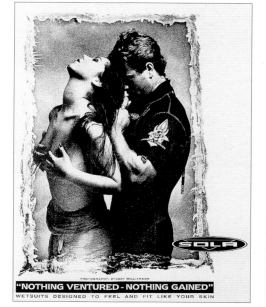
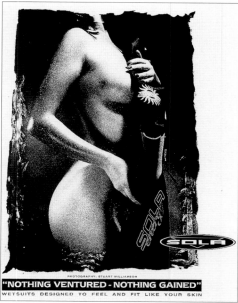

Images 1, 2, 3 & 4: Take time to plan a session and you will be rewarded with more than one strong and usable image, particularly if the session is thematic.

Image 5: All of the shoot was taken on 35mm using Contax cameras and lenses because of their excellent quality. This format was chosen to produce grainy images. This particular image is reminiscent of a deep sea angler who has caught a prize fish.

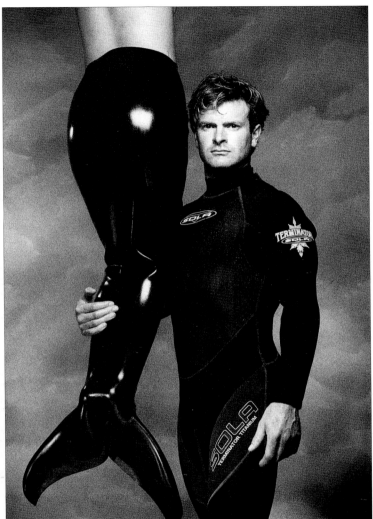

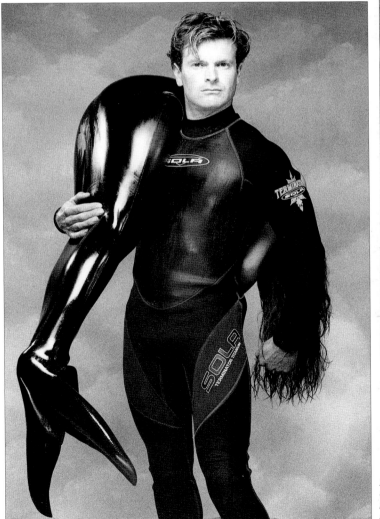

Image 6: This is a fairly basic straight print. Compare it with the finished image into which a lot of work has gone to produce something with dynamic impact.

Workshop

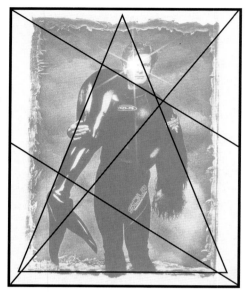

Compositional Rule: triangle and thirds.

TECHNICAL DATA

Model	• Simon & Correna	Props	• Sola Wetsuits,
Camera	• Contax RX		mermaid tail
Lens	• 85mm	Extras	• Muslin, spray bottle,
Film	• HP5 Plus, ISO 400		baby oil, Lastolite
Background	• Colorama		Tri-Flector
Lighting	• Bowens		
Paper	• Kentmere lith paper		

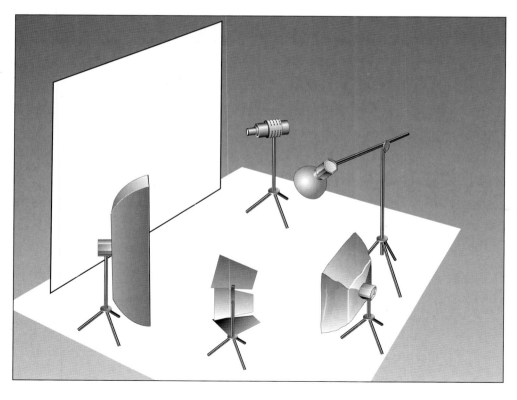

Lighting: The main light was a soft-dish approximately 15" in diameter, mounted on a boom stand. This unit had a central diffuser that provided an even, specular light.

A softbox was positioned to the right-hand side, to add fill-in, and a Tri-Flector to the left-hand side for further fill-in light.

A large strip-light was placed to the rear left, to rim-light the mermaid's tail. Finally, a focusing spot light illuminated the bottom right of the image.

Final Image (right): This was lith printed on Sterling paper to give the image more of an aggressive feel which was further enhanced by the grain of the 35mm film.

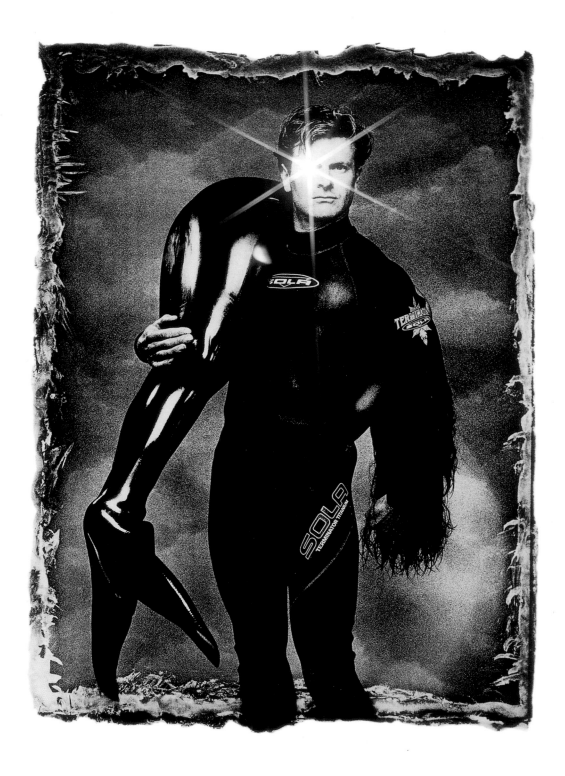

Terminator

Index